The College History Series

BELHAVEN COLLEGE

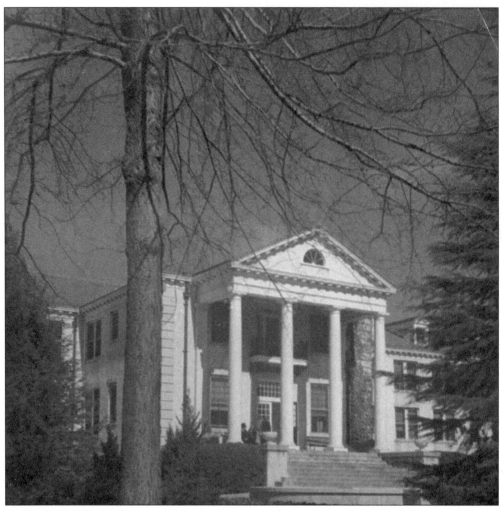

Fitzhugh Hall links the past with the present. After a major fire in 1927 destroyed the central portion of the original college building, Fitzhugh Hall was constructed out of one of the surviving wings.

The College History Series

BELHAVEN COLLEGE

PAUL R. WAIBEL

ARCADIA

Published by Arcadia Publishing,
an imprint of Tempus Publishing, Inc.
2 Cumberland Street
Charleston, SC 29401

Printed in Great Britain.

Library of Congress Catalog Card Number: 00-105483

For all general information contact Arcadia Publishing at:
Telephone 843-853-2070
Fax 843-853-0044
E-Mail sales@arcadiapublishing.com

For customer service and orders:
Toll-Free 1-888-313-2665

Visit us on the internet at http://www.arcadiaimages.com

This volume is dedicated to the many men and women
who have graduated from Belhaven College,
and who through their lives of service
to the college, their churches, and their communities
have exemplified the motto of the college:
"Not to be ministered unto but to minister."

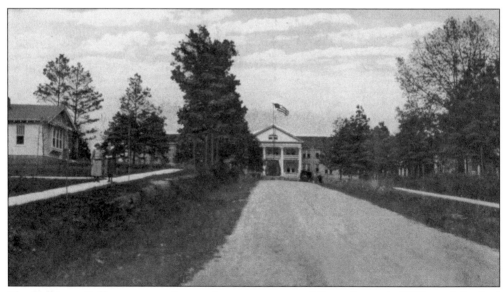

The Belhaven College campus is seen here on a postcard from the early 1920s, as it looked from Belhaven Street.

CONTENTS

ACKNOWLEDGMENTS

Much of the historical information contained in the introduction and the captions accompanying the images was taken from James F. Gordon Jr.'s *A History of Belhaven College*, published in 1983 by Belhaven College. Additional historical information was found in yearbooks, catalogs, and other publications preserved in the Belhaven College Archives, in the Heritage Room of the Hood Library. A very special debt of gratitude is owed to Miss Evelyn Tackett (class of 1956), curator of the college archives. Without her assistance and interest this volume could not have been completed. Finally, a hearty thanks is offered to the editorial and production staff of Arcadia Publishing, whose expertise transformed a diverse collection of images and captions into an attractive book, which it is hoped will provide hours of delightful browsing for the reader.

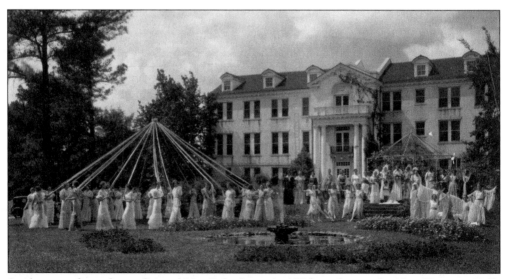

Students perform the traditional May Pole dance in 1934 on the south side of Preston Hall.

INTRODUCTION

Belhaven College for Young Ladies was founded in 1894 by Dr. Louis T. Fitzhugh. Located in Jackson, MS, the college occupied a large residence and spacious grounds that formerly belonged to Col. Jones Hamilton. The estate was named "Belhaven" after the colonel's ancestral home in Scotland. Just seven months after it opened, the college burned to the ground on February 7, 1895. New buildings were constructed, and the college reopened in the fall of 1896.

Following Louis Fitzhugh's death in 1904, the college was purchased and operated by James Rhea Preston between 1904 and 1911. In 1910, fire once again struck the college, resulting in a total loss of its buildings. In 1911, Dr. Preston gave the "name and goodwill" of the college to the Presbyterian Church. The college moved to its present Peachtree Street location, where it operated as Belhaven Collegiate and Industrial Institute until 1915, when the board changed its name to Belhaven College.

Rev. William Henry Frazer guided the college during the period between 1917 and 1921. Despite the hard times caused by America's involvement in World War I and the great influenza epidemic of 1919, enrollment reached a record of 182 students in 1919, 151 of whom were boarding students.

In 1922, Rev. Guy T. Gillespie agreed to become president of the college on condition that the board would agree to work with him in achieving accreditation for the college within two years. The best intentions of all concerned were thwarted, however, by subsequent events. Another major fire in 1927, the onset of the Great Depression, World War II, and the failure of the Presbyterian Church to provide promised financial support for the college made it impossible to meet the minimal standards for faculty salaries, library holdings, and endowment set by the Southern Association of Colleges and Schools for accreditation until 1946. In the meantime, Dr. Gillespie was able to have the college placed on an approved list of schools for teacher training by the Southern Association.

In 1939, Mississippi Synodical College of Holly Springs was consolidated with Belhaven College. During the 1930s and 1940s the college grew, achieving recognition especially for its music program, accredited in 1941 by the National Association of Schools of Music. Belhaven music faculty were instrumental in founding the Jackson Symphony Orchestra in 1944 and the Jackson Opera Guild in 1945. The college broadcast regular radio programs between 1930 and 1953. In 1933, Belhaven College put on the first performance of a "Singing Christmas Tree," an idea that has been widely imitated throughout the nation since then.

World War II presented new challenges. Enrollment declined by 10 percent, while war-related inflation forced the college to raise both fees for boarding students and faculty salaries. By 1951, the college faced its first, and only, operating deficit during Dr. Gillespie's tenure as president. From a peak enrollment of 310 full-time students in 1945, the college

dropped to an alarmingly low enrollment of 180 in 1951. Although Dr. Gillespie did not favor coeducation, he recognized the necessity of admitting male students if the college was to survive.

Enrollment for the fall of 1953 plunged to only 140 regular students, and in 1954, the Southern Association threatened to withdraw the college's accreditation. To rebuild the college, the new president, Dr. Robert McFerran Crowe, committed the school "to strive for academic excellence." Non-academic majors such as physical education and home economics were dropped, while entrance requirements and core requirements for a bachelor of arts degree were raised. The college became coeducational in 1954, and intercollegiate sports were introduced in 1957 to strengthen school spirit. The cumulative effect of these and other changes resulted in a better quality institution and a growing enrollment that passed 600 in 1965.

Belhaven College continued to progress during the tenure of Dr. Howard J. Cleland as president between 1961 and 1978. Perhaps the most significant change occurred in 1972, when the Synod of Mississippi turned ownership of the college over to its board of trustees, which became self-perpetuating. A covenant relationship was established with the newly organized Synod of the Mid-South, which provided for continued spiritual and financial support of the college by the Presbyterian Church, but not ownership or control.

In 1973, Dr. Verne R. Kennedy, a member of the class of 1963, became president of the college. Kennedy served until 1986, when Dr. I. Newton Wilson, also a member of the class of 1963, became president. Belhaven College, like most church-related, small private liberal arts colleges, struggled during the 1970s and 1980s to find a way to continue its mission as a distinctively Christian college in an era of a declining pool of potential students, rapidly changing technology that dramatically increased the costs of higher education, and changing demands and expectations from industry and the public as to what a college education should provide.

In 1986, the art department was accredited by the National Association of Schools of Art and Design, an honor for a college the size of Belhaven. Also in 1986, Ballet Magnificat, a professional ballet company, began on the Belhaven campus. In 1990, the first International Ballet Competition Village was located at Belhaven, giving the college an international exposure. Believing that the college's population as a Christian college should reflect the diversity present in the Body of Christ, the college actively recruited foreign and African-American students. African-American students began attending Belhaven College in the early 1970s. By the end of the century, Belhaven College ranked fifth in campus diversity among Southern liberal arts colleges.

During the 1990s, under the leadership of Dr. Newton Wilson and Dr. Roger Parrott, who assumed the presidency of the college in 1996, Belhaven College began an aggressive campaign to expand and modernize. The college became computerized and began an innovative continuing adult education program that offered B.B.A. and M.B.A. degrees. In 1999, a master of arts in teaching and a master of education in elementary education were introduced. By then, Belhaven College had satellite campuses in Memphis, TN, and Orlando, FL, and was on the verge of offering degree programs over the internet.

One

CAMPUS VIEWS

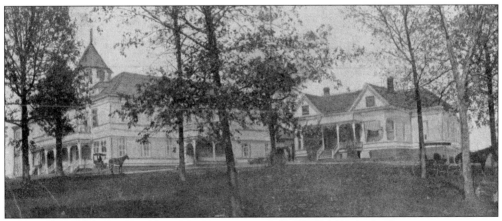

Belhaven College for Young Ladies was originally located on Boyd Street in Jackson, MS, a community of only 10,000 inhabitants in 1894. The college was housed in the former residence of Col. Jones Hamilton, and was named "Belhaven" after Colonel Hamilton's ancestral home in Scotland. No illustration of this original facility, destroyed by fire on February 7, 1895, is known to exist. Pictured above is the "new" structure built on the same location after the fire. The new "large and commodious" structure featured such modern conveniences as bathrooms with hot and cold water, a "steam heating apparatus," and incandescent lighting. The college offered courses of instruction leading to the A.B., B.S., or M.E.L. (Mistress of English Literature) degrees. Certificates in music, art, and elocution and high school diplomas were also awarded by the college.

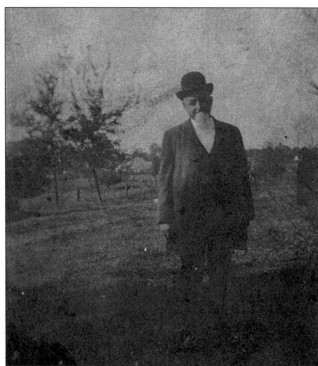

Belhaven was founded by Dr. Louis T. Fitzhugh, pictured here in a rare photo taken in 1902, just two years before his death. Dr. Fitzhugh was born in 1841. His entire adult life was spent in education. Before founding Belhaven College, he served as principal of Rankin Masonic Institute in Rankin County, University High School in Oxford, and president of Whitworth Female College in Brookhaven, MS.

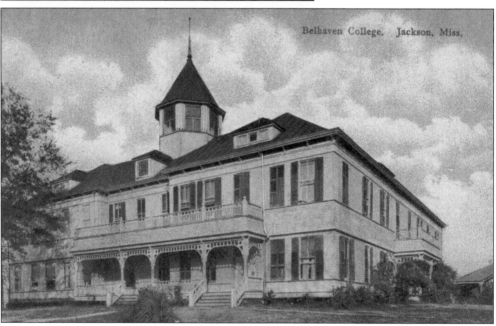

Boarding students at the Boyd Street college, pictured here on a postcard printed in Germany for the W.L. Brown Company of Jackson, were not allowed to receive "visits, notes, bouquets, or any other form of communication or marks of attention . . . from persons outside the College" without permission of the president. Day students were prohibited from acting as intermediaries between boarding students and persons outside the college.

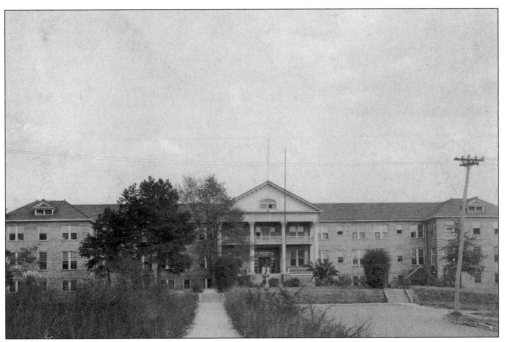

The "new" Boyd Street campus burned to the ground in a second major fire on October 19, 1910. Dr. James Rhea Preston, owner and president since 1904, donated the name and goodwill of the college to the Presbytery of Central Mississippi. The Presbytery constructed a new brick building that stretched a total of 250 feet on property along Peachtree Street, just blocks from the former Boyd Street location.

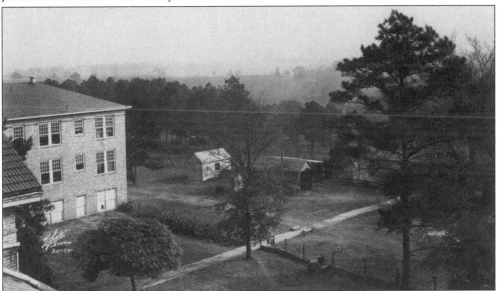

In the fall of 1911, the college reopened at its new location as Belhaven Collegiate and Industrial Institute. A truck garden, "to keep the table supplied with fresh vegetables," and a dairy to add to the college's budget were located on the 50-acre campus. The above picture shows the old laundry (behind the tree) and a garage, both located behind the main brick building.

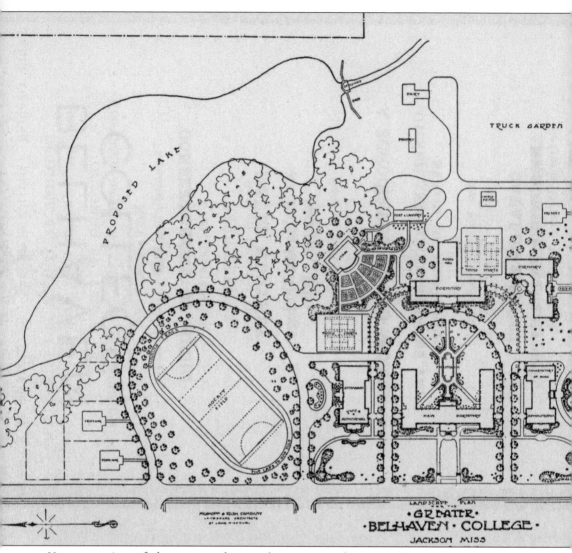

PROPOSED LAKE

DAIRY

TRUCK GARDEN

LANDSCAPE PLAN
·GREATER·
·BELHAVEN·COLLEGE·
JACKSON MISS

No map exists of the campus layout during its early years. This campus map, which appeared in the 1927 college catalog, is actually a vision of how Dr. Guy T. Gillespie hoped the campus might one day appear. Dr. Gillespie, Belhaven's fifth president, was apparently planning a renovation of the campus in 1926. A third major fire in 1927, the Great Depression, and World War II would prevent Dr. Gillespie's vision from being fully realized. The map does show the location of the original 1911 brick structure (the horseshoe-shaped building), as well as the truck garden and dairy. The proposed lake was constructed in 1925, although in a somewhat different shape and location. In 1998, the lake was partially filled in to make room for a practice field for the new Belhaven College varsity football team.

12

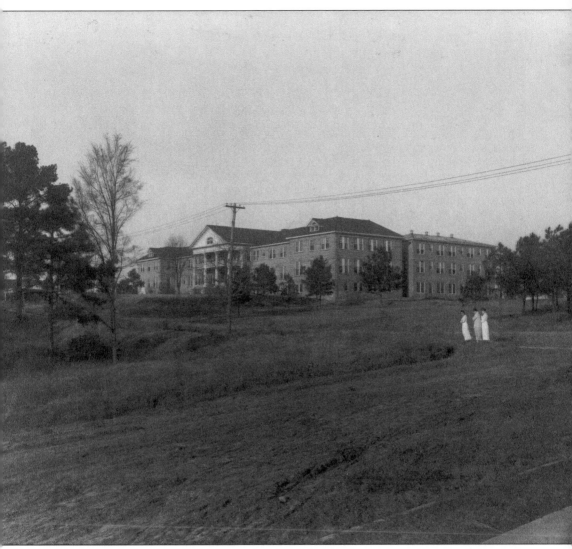

Although today the college is located in the heart of Jackson, it was in a very rural setting in the early 1920s. The three girls are standing at the corner of Peachtree and Pinehurst Streets. The house visible behind the pine trees on the left is still standing. Mud streets were paved over long ago, but the above ground power lines remain a part of the landscape. Boarding students arriving in Jackson by train were met at the station and escorted to the campus. Students were not allowed to leave the campus without permission of the president and unless accompanied by a teacher. Young gentlemen wishing to visit students during approved times had to first obtain permission from the girl's parents and present letters of reference to the president. All areas of life "pertaining to health, home life, or deportment of boarding students" were regulated by the college.

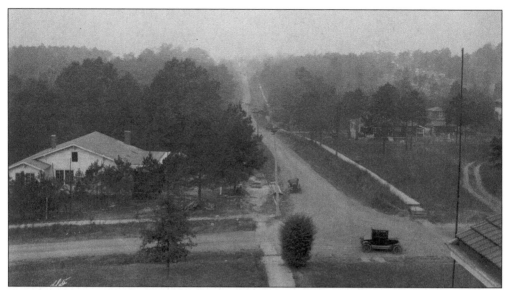

The rural nature of the area in the early 1920s is again apparent in this view, looking down Belhaven Street toward North State Street. The photograph was taken from the roof of what is today Preston Hall, the southern portion of the main building that survived the fire of 1927. The house on the left is the same house behind the pine trees in the previous picture.

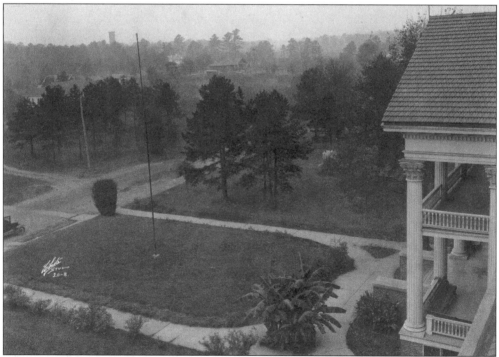

Taken at the same time as the previous two pictures, this view of the grounds in front of the main building also shows the attractive front porch and original red tile roof. The front porch was destroyed in the 1927 fire. It is where the "Lagoon" and white columns now stand. The car is parked on Peachtree Street.

Taken at the same time as the previous three pictures, this view from the roof of the college looks south down Peachtree Street. The two homes visible in the center of the picture are facing Pinehurst Street. The one on the left is on the corner of Peachtree and Pinehurst Streets. Both are still standing, contributing to the historic atmosphere of today's Belhaven neighborhood.

The original brick building included an elegant front porch that looked down Belhaven Street toward North State Street. Behind the tree stands the president's home. It was a peaceful, deep South atmosphere that permeated the campus during those early years.

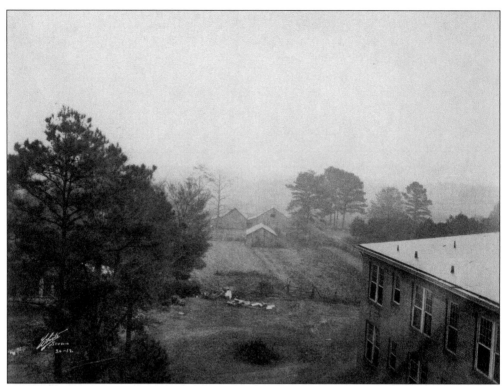

The farm and dairy located behind the main building provided much of the fresh food served during meals in the dining hall. All meals were served "family style." The quality of the food made possible by the farm and dairy was one of the attractive features of the college during the 1920s.

No specifics are known about this picture of Belhaven College's "prize bull." It does provide evidence that the college included a fully functional farm during its early years. A portion of the 55-acre campus was occupied by "a garden and pasturage for cows."

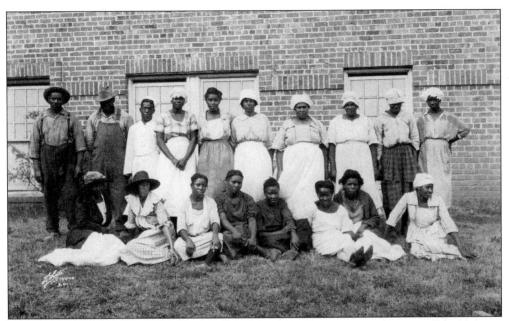

Most of the labor at the college was provided by African Americans. Here, the staff from the early 1920s is pictured next to the main building. Student workers were paid at the rate of 10¢ per hour in 1916. It is not likely that the employees pictured here were paid any more.

The campus dining hall is pictured here with tables set for family style dining. Georgine Flanders (class of 1922) recalled that a typical mid-day meal might consist of cold ham, sweet potatoes, spaghetti and cheese, turnip salad, and bread. The evening meal was more of a snack, and was likely to consist of a green salad, biscuits, peach butter, and ice tea, coffee, or milk.

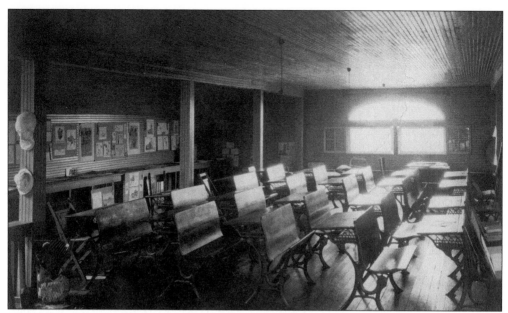

Desks in classrooms during the early years were those typical of schools during that era. Pictured here is the interior of what appears to be an art classroom. Some of the pictures on display have ribbons attached, indicating that they were awarded prizes. There is a metal frame bed beneath the window at the back of the picture. Note that the floor, walls, and even the ceiling are of wood, and not plastered over as one might expect.

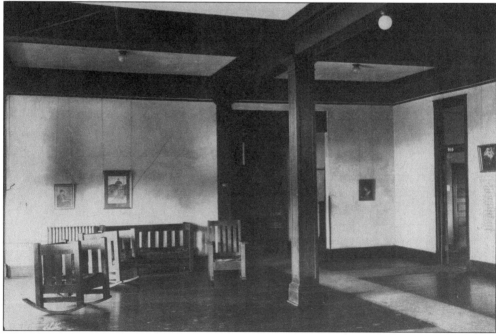

A corner of the main hall is shown with very plain and functional furniture. Here the walls are plastered. To the right of the doorway with the number "100" above it is a roster that appears to include room numbers and names. Whether these are faculty and staff offices or rooms used for other purposes is not clear.

The beautiful front porch and entrance are pictured here during the early 1920s. This is the portion that was destroyed during the fire on August 9, 1927. The portion to the right, visible behind the tree, survived the fire and became the present-day Preston Hall.

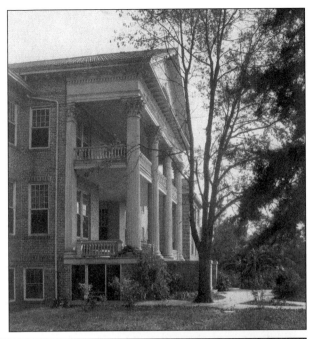

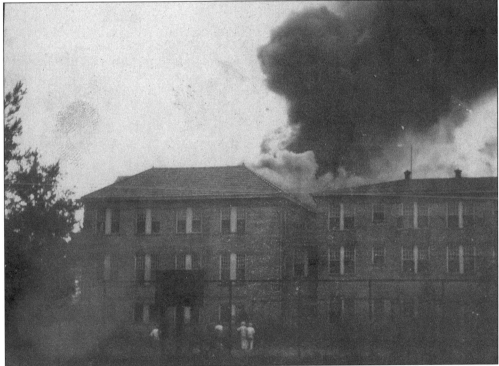

On the morning of August 9, 1927, lightning struck the central portion of the main building, igniting a fire that destroyed a major portion of the building and its contents. This rare photo taken from the basketball court on the south side of the building shows the fire in progress. Four men are standing in the foreground, unable to do anything to save the building.

CLASS OF SERVICE

This is a full-rate Telegram or Cablegram unless its character is indicated by a symbol in the check or in the address.

NEWCOMB CARLTON, PRESIDENT J. C. WILLEVER, FIRST VICE-PRESIDENT

SYMBOLS

BLUE	Day Letter
NITE	Night Message
NL	Night Letter
LCO	Deferred
CLT	Cable Letter
WLT	Week End Letter

Form 1201

The filing time as shown in the date line on full-rate telegrams and day letters, and the time of receipt at destination as shown on all messages, is STANDARD TIME.

Received at 2780 Broadway, New York

N46 8. JACKSON MISS 9 735A 1927 AUG 9 AM 9 10

G T GILLESPIE, JOHN J HALL.

COLUMBIA UNIVERSITY.

BELHAVEN ON FIRE ABSOLUTELY NO CHANCE OF SAVING.

JENNIE ARMISTEAD.

Dr. Guy T. Gillespie, president of the college, was on a train to Princeton University in New York when the fire began on August 9, 1927. Dr. Gillespie's secretary, Ms. Jennie Armistead, sent two telegrams to Dr. Gillespie reporting on the fire. The first was sent while the fire was in progress, advising him that the college was on fire and feared a total loss. The second informed him that the college was a "total loss," and that the board of trustees was scheduled to meet on the morning of the 10th to formulate plans for rebuilding. One can only imagine what must have went through Dr. Gillespie's mind as he read the telegrams. It was the third major fire in the college's short history of only 33 years. Like the two earlier fires in 1895 and 1910, this one would not mean the end of Belhaven College.

CLASS OF SERVICE

This is a full-rate Telegram or Cablegram unless its character is indicated by a symbol in the check or in the address.

NEWCOMB CARLTON, PRESIDENT J. C. WILLEVER, FIRST VICE-PRESIDENT

SYMBOLS

BLUE	Day Letter
NITE	Night Message
NL	Night Letter
LCO	Deferred
CLT	Cable Letter
WLT	Week End Letter

Form 1201

The filing time as shown in the date line on full-rate telegrams and day letters, and the time of receipt at destination as shown on all messages, is STANDARD TIME.

Received at 2780 Broadway, New York

N126 10. JACKSON MISS 9 1055 1927 AUG 9 PM 12 21

A G T GILLESPIE,

CARE JOHN J HALL. COLUMBIA UNIVERSITY.

BELHAVEN TOTAL LOSS BOARD MEETING THIS MORNING FORMULATE

PLANS REBUILD.

JENNIE ARMISTEAD.

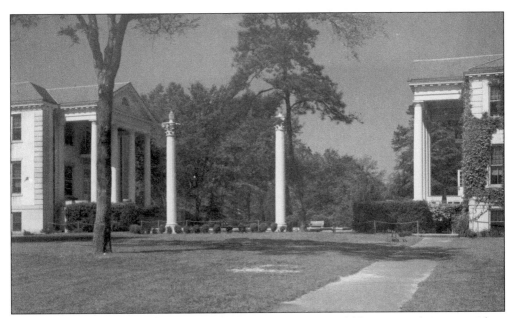

When the damage caused by the fire on August 9, 1927, could be assessed, it was evident that the building was not a total loss as feared. The north and south wings survived, while the middle section was totally destroyed. After much deliberation, it was decided to restructure the two surviving wings as two separate buildings. The result, pictured here at a much later date, was Fitzhugh Hall on the right and Preston Hall on the left.

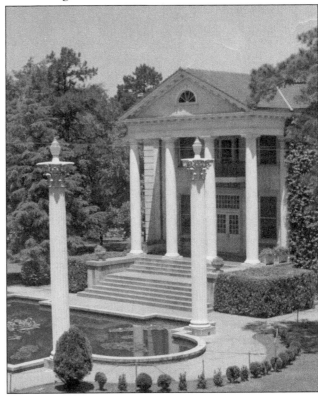

A pond, known as the "Lagoon," was placed between the new Fitzhugh (pictured here) and Preston Halls. The two pillars were two of the original four pillars from the front porch that somehow survived the fire. The estimated cost of reconstruction was $116,500, most of which was covered by insurance.

When the surviving wings were restructured as Fitzhugh and Preston Halls, the old brick facing was covered with stucco and painted white, as it remains today. This picture was taken the eastern end of Fitzhugh Hall.

This picture taken from the eastern end of the central campus presents a tranquil scene. Taken during the winter months, perhaps over a Christmas break during the late 1940s, the absence of leaves on the trees allows the viewer to see Preston Hall on the left and Fitzhugh Hall on the right. The Lagoon with white columns in the center of the picture had become by then the most readily recognizable symbol of the college.

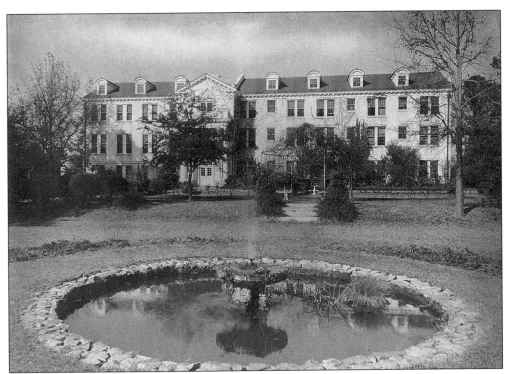

The south side of Preston Hall during the 1940s opened onto a pleasant scene. The pond and fountain have since been replaced with a circle of bushes. The arbor has disappeared also. All that remains are the concrete steps and benches.

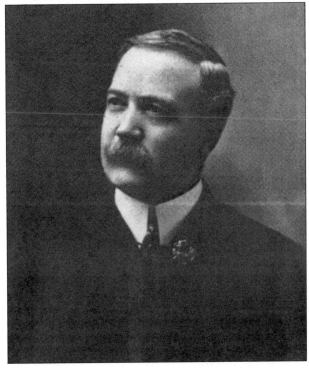

When Preston Hall was created out of the south wing of the old building, it was named in honor of Dr. James Rhea Preston, Belhaven College's second president. Dr. Preston was educated at Georgetown University, Emory and Henry College, and the University of Edinburgh, Scotland. A member of the Mississippi bar, he served as a high school teacher, Mississippi State superintendent of education, and president of Stanton College in Natchez before coming to Belhaven.

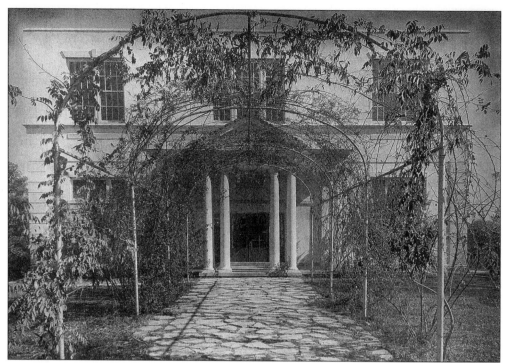

Lancaster Hall was constructed as a single-story structure in 1928. In 1939, a second story was added. The dining hall was located on the ground floor, and the college library was located on the second floor. Located between the present-day Irby Hall and Bailey Student Center, Lancaster Hall served the college until it was demolished in 1988–89.

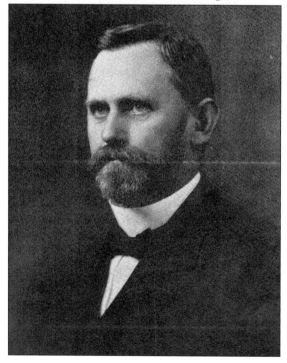

Lancaster Hall was named in honor of Rev. Richard Venable Lancaster, who served as Belhaven's president between 1911 and 1915, the period during which the college was known as Belhaven Collegiate and Industrial Institute. Dr. Lancaster served as president of McComb Female Institute in McComb, MS, before coming to Belhaven. He resigned in 1915 to take a position in Virginia.

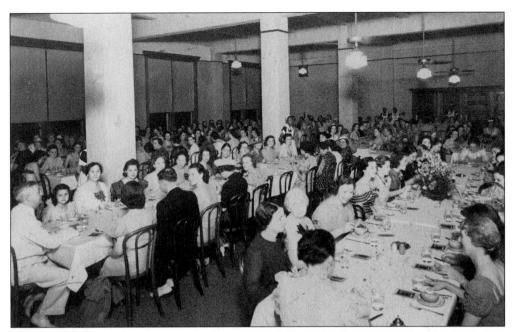

The dining hall in Lancaster Hall was the scene of this spring banquet during the 1930s. Dr. Gillespie is seated at the head of the table on the left. Note the bells beside the head of each table for summoning the staff standing at the back of the hall.

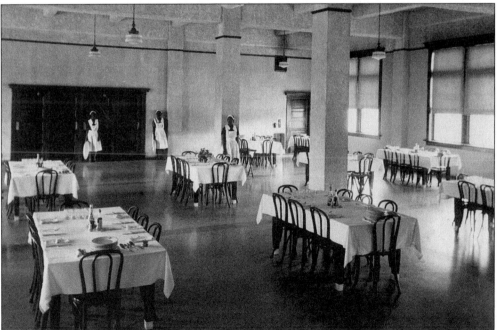

In this picture from the 1930s, the dining hall is set for students to dine "family style," eight to a table. Students were assigned to tables, and rotated from one table to the next at regular intervals. Notice the staff awaiting the arrival of the students. Alumni observing the cafeteria-style dining of today's colleges might be tempted to refer nostalgically to this as "civilized dining."

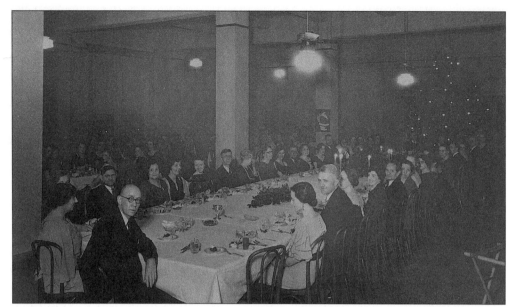

Maj. W. Calvin Wells, chairman of the board of trustees between 1915 and 1953, is seated at the head of the table, looking at the camera, during this Christmas banquet in Lancaster Hall during the early 1950s. Mrs. Gillespie is seated to the major's left. The empty chair must belong to Dr. Gillespie, who is apparently taking the picture.

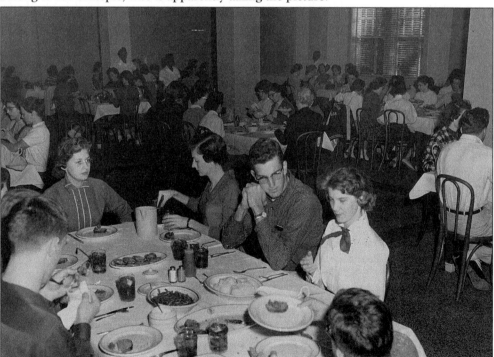

Students still dined family style, *c.* 1956.Certain tables were designated for seniors, and all other students were assigned to specific tables each month. A faculty member was assigned to each table. After Christmas break in 1958, students returned to campus to find that this style of dining had given way to the latest trend in college dining, the cafeteria.

26

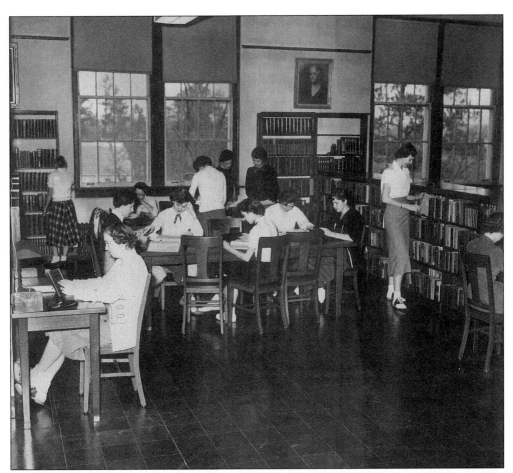

Ms. Elizabeth T. Newman's portrait hangs on the wall of the library named in her honor. The library was located on the second floor of Lancaster Hall until the construction of Hood Library in 1974, named in honor of Warren A. Hood, chairman of the board of trustees from 1973 to 1987. As late as 1962, the library's holdings totaled only 24,000 volumes. The need to increase the library's holdings was a continuous problem during Dr. Gillespie's presidency. The inability to find funding to increase the library's holdings was one of the three shortcomings regularly cited by the Southern Association of Colleges and Schools as a reason for not granting full accreditation. The college's failure to meet minimum requirements for faculty salaries and endowment were the other two shortcomings cited. As noted earlier, the fire of 1927, the Great Depression, and inflation triggered by World War II all contributed to the financial woes of the college.

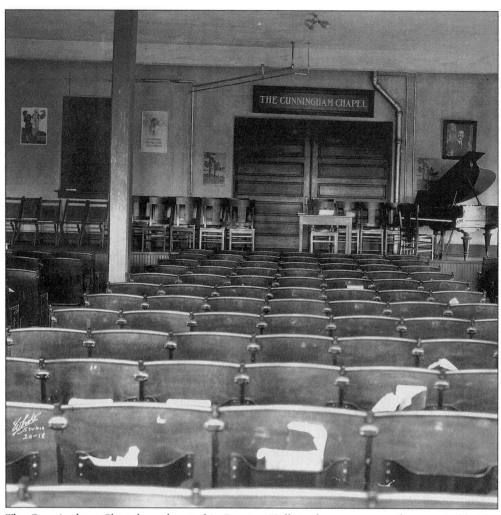

The Cunningham Chapel was located in Preston Hall, in the area currently occupied by the president's office and development offices. When the college was founded, students were required to attend daily chapel services, in order "to hear the readings of Scriptures and to engage in singing and prayer." Although students could attend churches of their choice on Sundays, Sunday school and Sunday evening prayer meetings were held on campus. No mention is made of daily chapel services in the 1927 catalog, but students were expected to attend Sunday school and worship services at churches of their choice. Sunday vesper services were held in Cunningham Chapel. Although Belhaven College was a Presbyterian college, no requirement was made of any student that would be contrary to the individual student's belief. The faculty and student body was made up of members of various evangelical churches. According to the 1927 catalog, the college "was born of the conviction that 'The Soul of Education is the education of the soul,'" and its mission was to provide its students with "the highest educational and cultural advantages under positive religious influences."

Mr. J.J. White (right) and family donated their stock in the McComb Female Institute to help establish the college at its present Peachtree location. The property of the McComb Female Institute was sold in the summer of 1911. Proceeds from the sale helped to finance the building of Belhaven Collegiate and Industrial Institute.

Mr. Hugh L. White, son of J.J. and Helen E. White (left), served as governor of Mississippi from 1936 to 1940 and 1952 to 1956. In 1929, he donated $50,000 to the college for the construction of a new dormitory to be erected as a memorial to his mother.

29

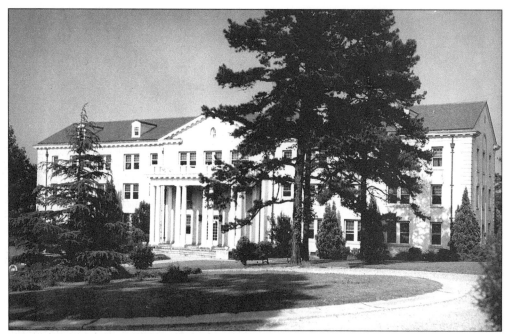

Helen White Hall was completed in time for the 1930–31 session. When it opened, the new three-story dormitory housed 40 freshmen girls. During the 1928–29 session, 174 boarding students and 12 faculty members were crowded into Preston and Fitzhugh Halls. Helen White Hall was converted into a men's dorm in the fall of 2000.

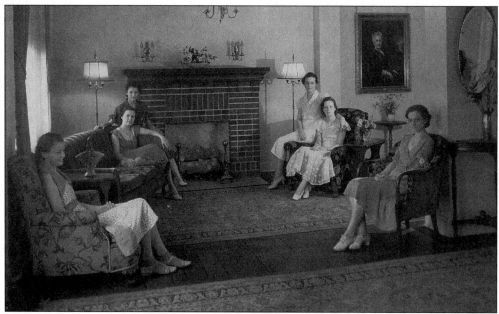

When finished, Helen White Hall included an attractive parlor. Mrs. White's portrait hangs on the wall to the right of the fireplace. During the 1990s, student health services operated out of Helen White Hall. Between 1961 and 1977, the college maintained an 11-bed infirmary in Preston Hall, staffed by a nurse. Physicians were engaged to make regular visits to the campus.

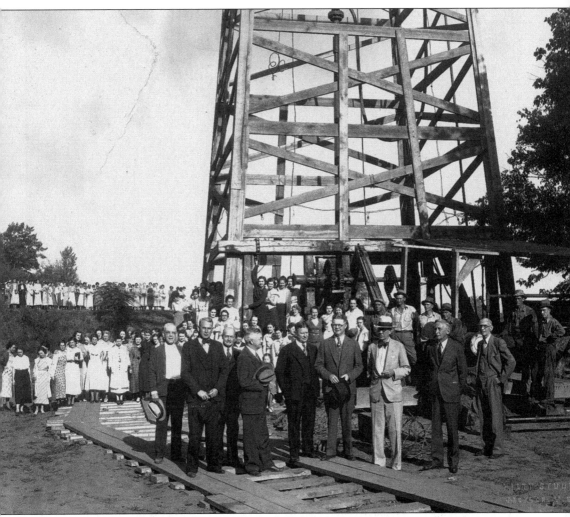

Mr. B.B. Jones, a Mississippi businessman and philanthropist, supplied the funds with which to drill a gas well on the campus in 1932. In this publicity picture taken upon completion of the well, Dr. Gillespie is the fourth gentleman from left, standing with hat in hand facing right. It is not known which gentleman is Mr. Jones. The well continued to meet the natural gas needs of the college until 1983; it was plugged in 1991. Belhaven College, like other small, private colleges, especially Christian colleges, is able to survive and prosper only because of the generous support of private donors who believe in its mission and choose to support it. Belhaven has benefited over the years from the generosity of Christians who saw their financial support of the college as a part of their stewardship responsibilities over the property entrusted to them by the Lord.

In 1939, the Synod of Mississippi approved the consolidation of Mississippi Synodical College of Holly Springs with Belhaven College. Mississippi Synodical College was founded in 1883. In 1957, the board of trustees recognized 1883 as the founding date of Belhaven College. Dr. Robert C. Cooper, president of Mississippi Synodical College, became vice-president of Belhaven College and chairman of the department of foreign languages and history.

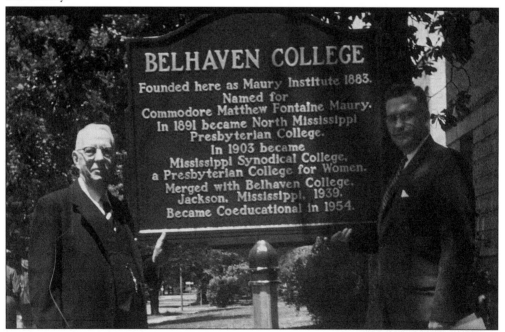

Dr. Robert C. Cooper (left) and Dr. Robert McFerran Crowe (right) stand beside the historical marker in Holly Springs, MS, that summarizes the history of Belhaven College. Dr. Cooper served as acting president in 1960–61. Dr. Crowe served as president of the college between 1954 and 1960. A room in the Bailey Student Center was later named in Dr. Cooper's honor.

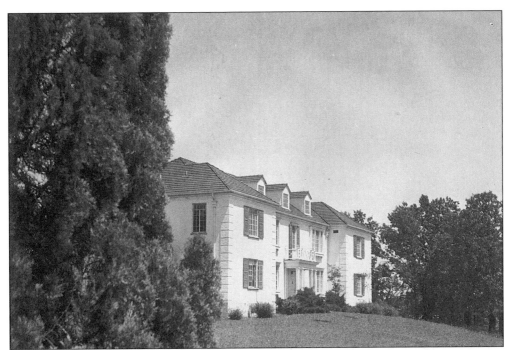

Raymond Hall was constructed in 1940 on the east side of the campus off Greymont Street and named in honor of Dr. T.W. Raymond, who served as president of Mississippi Synodical College from 1891 to 1929. Intended as an apartment building for faculty, it served as a practice home for the home economics department. In 1955 (after the college became coeducational in 1954) a portion of Raymond Hall became a temporary men's dorm.

"The Bowl," located between Caldwell Hall and Heidelberg Gym, contained a soccer field. In 1963, the annual Singing Christmas Tree was moved from the Lagoon to the Bowl. The college lake, constructed in 1925, can be seen through the trees.

The college lake was constructed in 1925 with funding provided by Mr. J. Baxter. Belhaven already possessed a wooded campus that provided many opportunities for walking and horse back riding. The addition of a lake added canoeing and boating to recreational opportunities available to students. During Dr. Gillespie's tenure, the lake provided an attractive backdrop for the May Day celebrations that were a favorite of the president. When Gillespie Hall was constructed in 1997, approximately half of the lake was filled in to provide space for a practice field for the college's new varsity sport, football.

34

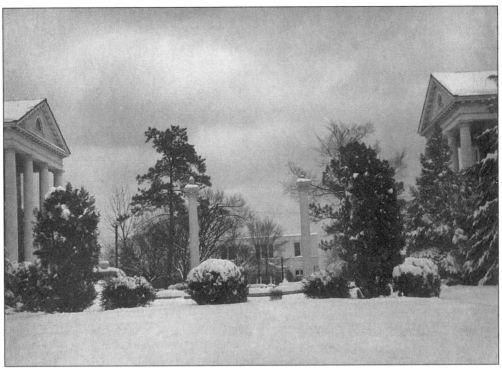

Snow is rare in central Mississippi, but when it comes it can provide some beautiful scenes. Here, the campus is seen covered in a blanket of white snow in the early 1950s. The picture was taken from the front of the campus, looking east through the Lagoon and columns toward Lancaster Hall.

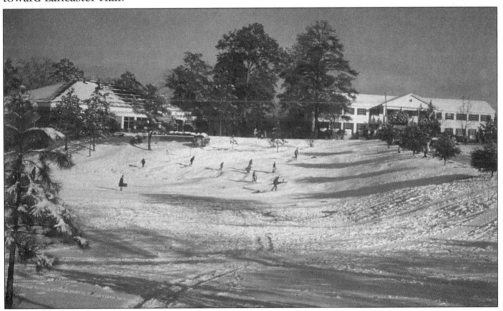

The Bowl is covered in snow, providing a rare opportunity for students to engage in winter games. Heidelberg Gym is on the left and the Fine Arts Building is on the right. The Fine Arts Building was the Recreation Building prior to the construction of Heidelberg Gym.

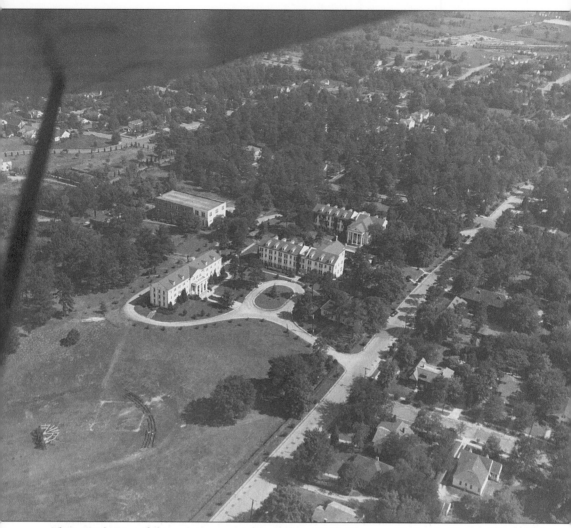

This aerial view of the campus was taken before 1949. Preston, Fitzhugh, Helen White, and Lancaster Halls are clearly visible. The president's home can be seen amidst trees just below Fitzhugh Hall. Raymond Hall is visible between the struts of the airplane's wing. The main street in front of the campus is Peachtree Street.

Two

ACADEMICS AND ARTS

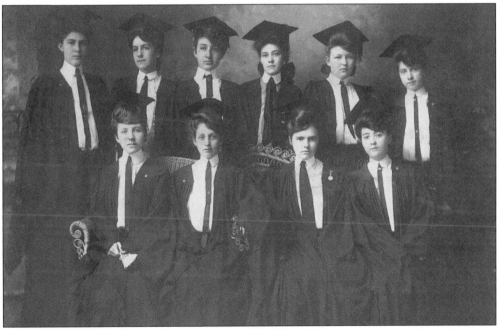

The graduating class of 1904 of Belhaven College for Young Ladies consisted of the ten ladies, pictured here in their graduation regalia. They are as follows, from left to right: (seated) Mabel Johnson (Galloway), Annie Dixon, Syme Ratliff, and Visa Harris; (standing) Grace Morford, Mary Sivley (Fields), Aleyne Asher (Hahn), Myrtle Green (McLean), Jodie Daly, and Hattie Brister. The college did not publish an annual until 1907. The 1907 *Miss-Lou* listed ten social clubs and three national sororities, Beta Gamma, Theta Zeta, and Mu Delta. The *Miss-Lou* was published again in 1909. An annual was published in 1914, 1915, and 1916 titled *Aurora*, meaning "dawn." In 1917, the annual was titled *Bubbles*. No annual was published in 1918 due to America's involvement in World War I. From 1919 through 1940, it was titled *Kinetoscope*. Since 1941, it has been known as the *White Columns*.

Miss Maggie Lee Bryant (Mrs. W.I. Stone) was a member of the class of 1907. She is pictured here as she appears in the 1907 *Miss-Lou*. Miss Bryant served as business manager of the *Miss-Lou*, vice president of the YWCA, secretary of the senior class, and was a member of a number of academic and sport clubs at the college. She was awarded the B.S. degree. Rule number seven of the "General Regulations for Boarders" in the 1908–1909 college catalog states: "It is especially desired that the dress of students be simple, modest, and inexpensive, and extravagant graduating dresses will not be allowed."

Miss Marian McNair (Mrs. Marian Caraway) was a member of the class of 1916 and recipient of the B.A. degree. The 1916 *Aurora* lists her as having been class poet and president of the Calvin Wells Literary Society during the first term, as well as a member of the German and French clubs, Theta Zeta sorority, and an active athlete (basketball). The Senior class of 1916 won first prize in the automobile parade at the 1916 Mississippi State Fair.

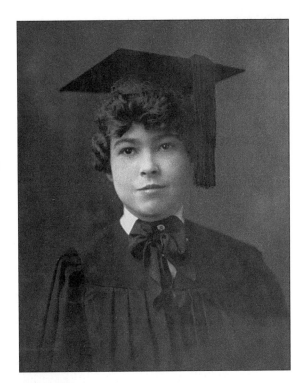

Miss Mathis T. "Missie" Robinson (Mrs. Lindsey McKee) from Centreville, MS, was president of the class of 1916. She was active as an officer in several academic clubs, including president of the Calvin Wells Literary Society during the second term. The Literary Society was founded in October 1915 by members of the senior class, and named in honor of Maj. W. Calvin Wells, chairman of the board of trustees from 1915 to 1953.

Miss Martha Gwin Hutton (Mrs. Fulton Thompson) was president of the class of 1917. She was treasurer of the Calvin Wells Literary Society and a member of many clubs. She was awarded the B.A. degree.

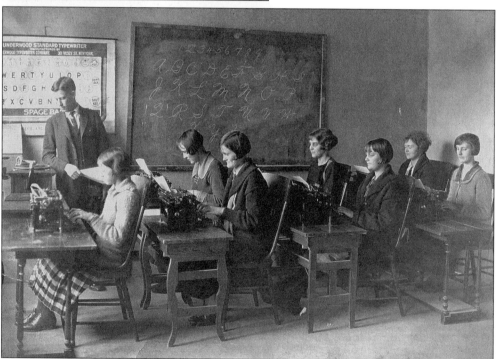

The industrial department of Belhaven Collegiate and Industrial Institute offered a certificate for a one or two-year curriculum that included typewriting, dictation, filing, business letters, and legal forms. In the picture above, the teacher is looking at a hand-cranked phonograph, as the students attempt to type what they hear. Notice the variety of desks, or tables.

Rev. William Henry Frazer served as Belhaven's fourth president from 1917 until 1921, when he resigned to become president of Queens College in Charlotte, NC. During Dr. Frazer's term, which corresponded with America's involvement in World War I and the Spanish influenza epidemic of 1919, Belhaven's enrollment rose to 230. Despite raising inflation, Dr. Frazer doubled annual faculty salaries in 1919 to $100.

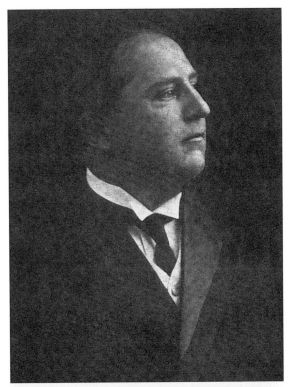

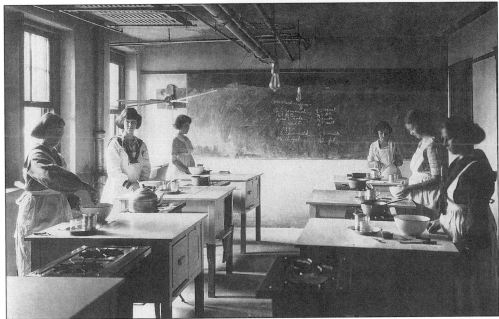

Domestic science, or home economics, was a popular subject area for the Belhaven students of yesteryear. Here, studentsin a class during the 1920s are making cornbread muffins from a recipe on the blackboard. The recipe calls for 2 cups cornmeal, 1 1/2 teaspoons baking power, 1 teaspoon salt, 1 egg, 1 cup sour milk, and 1 1/2 tablespoons of fat. *Bon Appetit*!

This picture of a "Class in Foods and Cookery" appears in the 1927 *Kinetoscope*. Perhaps the most obvious difference from the previous picture is the changing hair styles and dress of the students. The lady in the back dressed in black may be Ms. May Ellen Haddon, the home economics teacher.

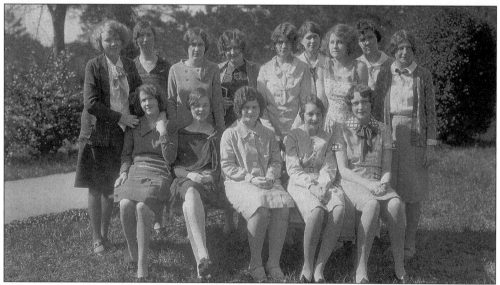

Members of the 1929 home economics club are pictured above on the campus. By 1929, the college was having to make small curriculum changes annually in order to keep up with requirements established by the Southern Association. When Dr. Frazer resigned in 1921, he advised the board of trustees that the college had to obtain full accreditation if it were to continue. His successor, Dr. Gillespie, devoted his career as president to that goal.

Miss Louise Mimms (Mrs. Thomas Girault) was a member of the class of 1924. She joined the faculty in 1939 as a speech teacher, and served until 1953. In 1963, when the Hidelberg Gymnasium was constructed, the old Recreation Building was renovated and renamed the Fine Arts Building. The former gym was converted into an auditorium and named in honor of Louise Mimms Girault.

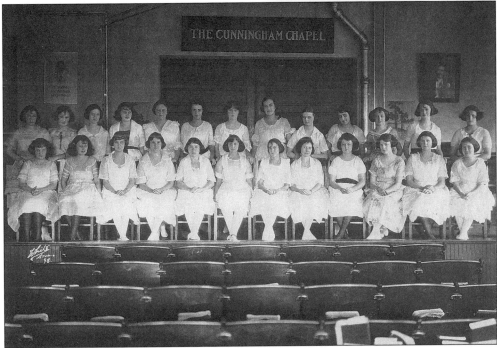

Mrs. Edyth Thompson's voice class (also the Glee Club) of 1922 is shown here in Cunningham Chapel. With the appearance of Girault Auditorium, the area occupied by Cunningham Chapel in Preston Hall was converted into administrative offices.

Pictured above are the "four Lewis sisters," daughters of Mrs. Henry L. Lewis, who graduated from Belhaven between 1920 and 1927. They are seated on a bench in front of the original building next to the front porch. Seated from left to right are Pearl E. Lewis (class of 1920) and Ethel Stanley Lewis (Mrs. William E. Conger, class of 1923). Standing from left to right are Aline Morris Lewis (Mrs. Allison White, class of 1927), Mrs. Henry L. Lewis, and Katherine Lewis (Mrs. R.P. Briscoe, class of 1918). The Naval ship USS *Briscoe* was named in honor of Katherine Lewis' husband, Adm. Robert P. Briscoe. It was the USS *Briscoe* in 1999 that carried the remains of John F. Kennedy Jr. and his wife and sister-in-law to their final resting place at sea off the coast of Martha's Vineyard.

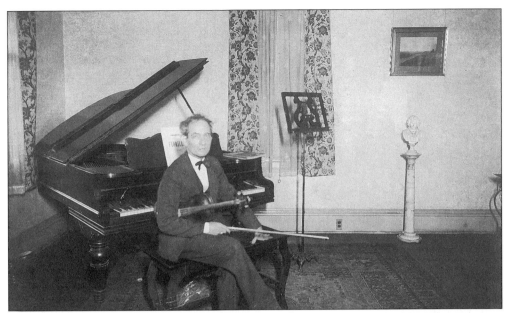

Mr. Robert C. Pitard, pictured here in his studio during the 1930s, was hired by Dr. Frazer to be head of the music department. Mr. Pitard was a graduate of Stern's Conservatory in Berlin. He taught violin at Belhaven College from 1917 to 1947. During those years the music faculty of Belhaven College played an important role in the founding of both the Jackson Symphony Orchestra and the Jackson Opera Guild.

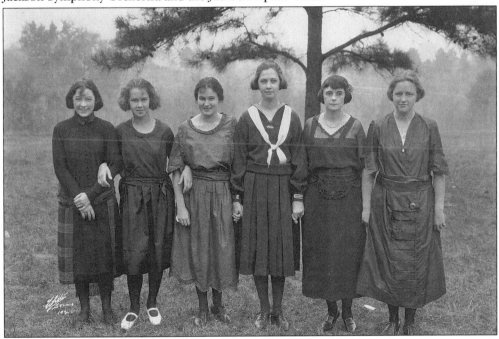

Mrs. Bartlett Bishop and her piano class of 1922 are shown on the campus grounds. Pictured from left to right are Elma Foster, Martha Hyland, Maurine McInnis, Rebecca Cowen, Mrs. Bishop, and Irene Caldwell. Mrs. Bartlett was a graduate of Lexington Ladies' College and Central College for Women. She taught at Belhaven from 1920 to 1922.

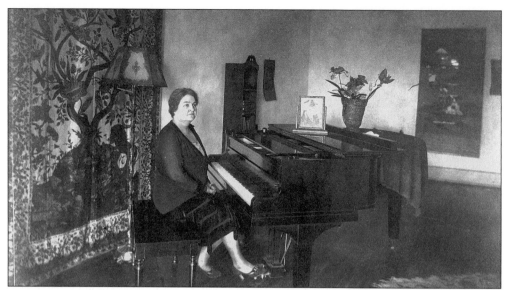

Mrs. Mignonne Howell Caldwell, or "Miss Non" as she was called by those who knew and loved her during her 38 years (1924–1962) as a member of the music faculty, is seated at the piano in her studio in 1930. Mrs. Caldwell served as head of the voice department for many years. A new women's residence hall was constructed on Peachtree Street in 1966–67, and name Caldwell Hall in her honor.

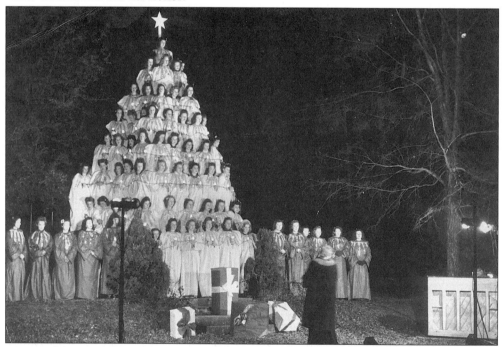

The Singing Christmas Tree, pictured here in the 1940s, was begun by Mrs. Mignonne Caldwell. The first performance was held in 1933 at the height of the Great Depression. The idea has been copied across the nation since then, but Belhaven College's claim to being the first is well established, and only Belhaven may legally claim to have the "original" Singing Christmas Tree. In 1963, the annual performance was moved from the Lagoon to the Bowl.

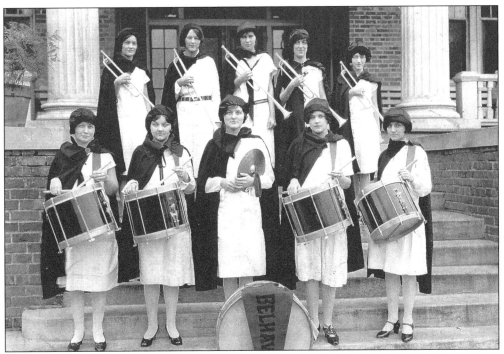

This picture of the drum and bugle corps appears in the 1927 *Kenetoscope*, but without any explanation. Twenty-nine girls are listed beneath the picture in the annual. There is no mention of the group in the 1927 college catalog. Perhaps it was a club that existed for only a short period.

Miss Mary Wharton's piano class (*c.* 1927) is pictured on the grounds in front of what later became Preston Hall. They are facing Peachtree Street. Piano was a separate department within the Belhaven Conservatory of Music. In addition to Miss Wharton, the 1927 college catalog lists Miss Lillian Rogers and Miss Juliette Chamberlain as faculty members.

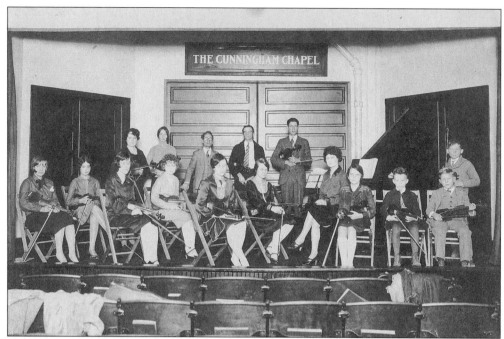

The Belhaven Orchestra is assembled in Cunningham Chapel in 1927. Mr. Pitard is standing in the back, third from the left. Mrs. Pitard was a member of the orchestra in 1927, and may be the lady seated at the piano, seventh from the left. Notice that there are four children in the orchestra. The 1927 *Kenetoscope* lists 24 members in all.

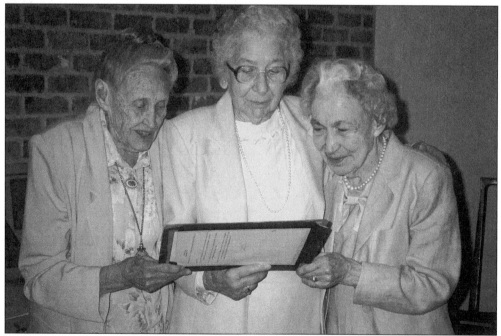

Three members of the class of 1925 are shown at a class reunion in 1995. They are, from left to right, Ann Parish Markham, Janet McDonald, and Dora McInnis Clayton. The three alumni are looking at the class picture taken on the steps of the front porch (see p. 49).

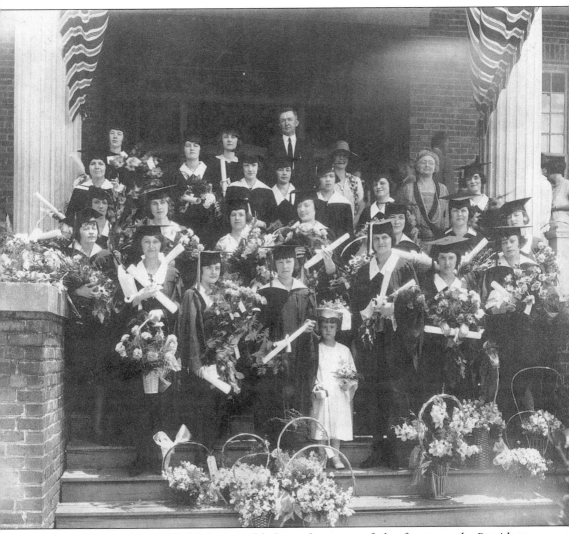

The graduating class of 1925 is assembled on the steps of the front porch. President Gillespie is standing in the center at the back. The second lady to Dr. Gillespie's left (sixth person from left in back row) in a dress with string of pearls is Mrs. Elizabeth T. Newman, who served as an English teacher and dean of the faculty. Although she was deeply loved by all who knew her (four yearbooks were dedicated to her between 1915 and 1942), this is the only known picture of her smiling. Of the three ladies at the 1995 class reunion (see the previous page), Ann Parish Markham is the second from left in the first row; Dora McInnis is fourth from left (third from right) in the second row; and Janet McDonald is second from left in the third row.

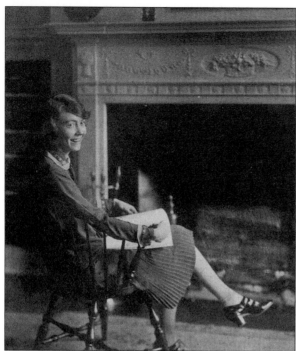

Miss Alice Watkins Wells was featured as "most scholarly" in the 1926 *Kinetoscope* and "most pleasing personality" in the 1927 *Kinetoscope*. She graduated from Belhaven College in 1927 with a B.A. degree in English and Latin. After receiving an A.M. degree from the University of Mississippi, she returned to Belhaven College and served as a member of the English faculty from 1930 to 1946.

Three alumni of Belhaven College are shown here at a homecoming celebration. They are, from left to right, Thora Helen Cooper (Mrs. Clinton A. Westervelt Jr.), class of 1961; Elvie McCormick (Mrs. J.C. McMurphy), class of 1918; and Ida Dorrah (Mrs. G.R. Bennett), class of 1895.

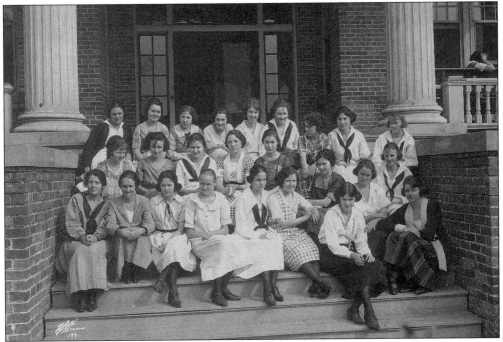

A group of students known as the "Scholarship Girls" are assembled on the steps of the front porch during the late 1920s. A number of scholarships were available to students of limited means, as well as student loans. Employment of students by the college was another means of providing financial assistance.

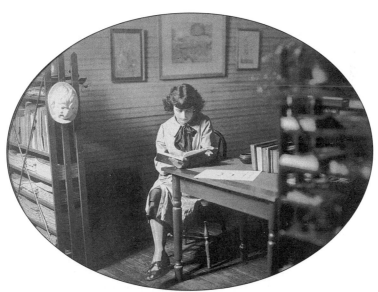

This picture of Mary Redfern reading in the art room is from the 1926 *Kinetoscope*. The picture as it appears in the yearbook is titled, "Mary Redfern=The Artist." Art classes at the time were taught by Ms. Bessie Carey Lemly, who received her training in art in New York.

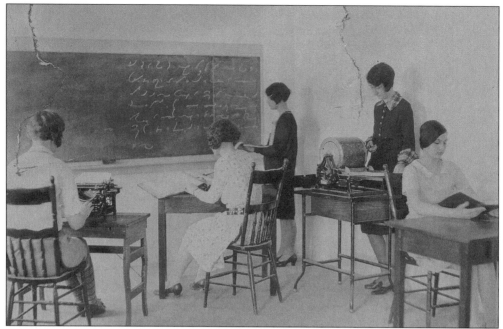

Students are busy at a variety of tasks in a classroom in the commercial department in 1928. The School of Business Training offered a "Business Certificate" for completion of courses in bookkeeping, stenography, typewriting, business English, and commercial law.

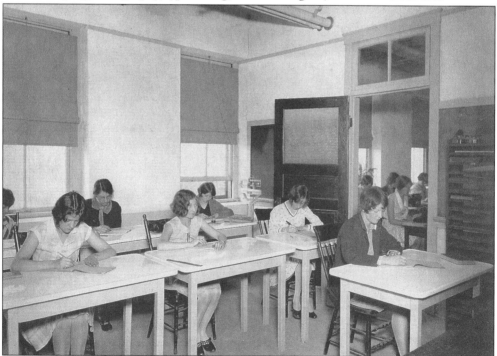

Students in this 1929 business class are apparently taking dictation. In 1929, students at Belhaven were charged $150 for tuition plus $300 for room and board per year. Students in the School of Business Training were charged an additional $20 typewriting fee.

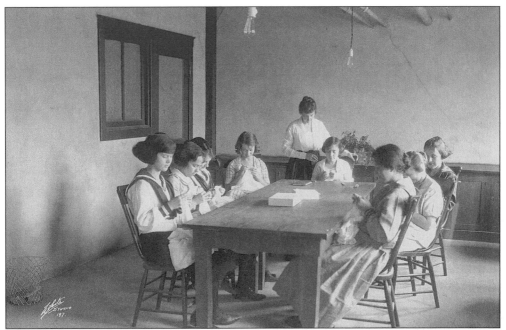

Students are seated around a table in the home economics department in 1922 for a sewing class. The teacher standing at the back is probably Mrs. Mattie Cavett Thompson. One of the three goals of the home economics department, as stated in the 1921–22 college catalog, was "To create an interest and love for the most universal and essential employment, home making, the selection and preparation of food and clothing."

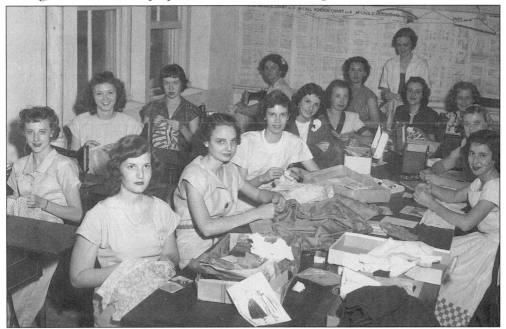

Elementary Sewing was still offered by the home economics department as late as 1964. The classroom is more crowded than in 1922, and there are charts hanging on the walls, but the basic course work appears still to require needle and thimble.

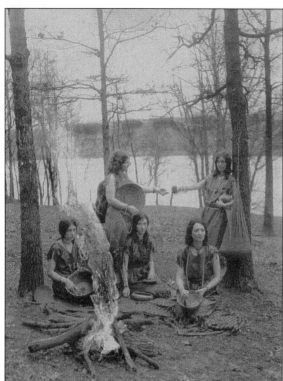

"The First Home-Makers" was a dramatic presentation put on by the drama club down by the college lake in 1929. The drama club was formed by students in the department of expression as "an organization for the study and promotion of the best forms of Dramatic Art." The club staged several programs each year.

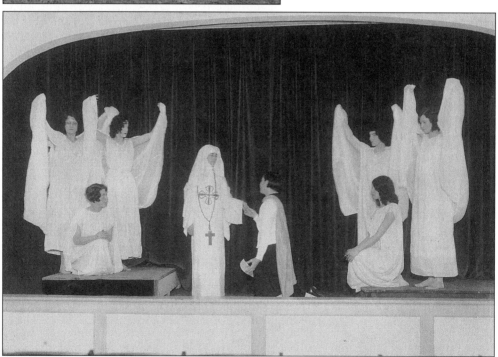

The drama club staged the Spanish play *Don Juan Tenorio* in Cunningham Chapel in 1929. The photograph shows the last scene. All dramatic work of the college during the 1920s was conducted through the department of expression.

54

The Ensemble Class of 1927 poses in the regulation fall and spring uniform. "The fall and spring uniform," notes the 1928 college catalog, "consists of a simple one piece dress of some heavy white wash material such as linen, poplin, etc." This and other regulation dress could be purchased at wholesale prices through the dean's office.

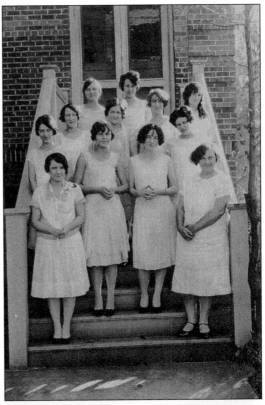

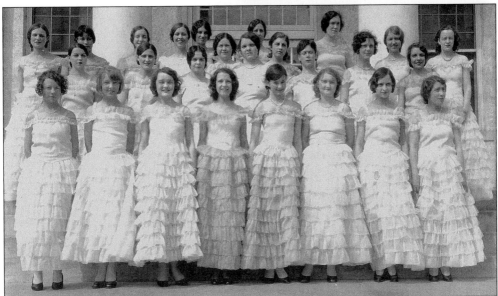

The 1930 Glee Club poses on the steps of either Fitzhugh or Preston Hall. Miss Bess Caldwell (see p. 56) is the eighth from the left in the first row. The glee club was composed of students with a special talent for singing, organized under direction of the department of voice. They performed "interesting and highly entertaining concerts" from time to time on campus and throughout the state.

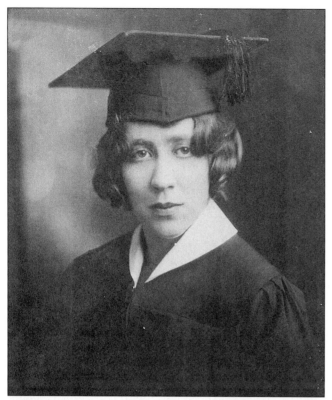

Bess Caldwell was a member of the class of 1930. She was president of her senior class and a member of numerous clubs and sororities. It is written of her in the 1930 *Kinetoscope*: "The secret of being loved is in being lovely, and the secret of being lovely is in being unselfish." Bess Caldwell was employed by Belhaven College from 1939 until her retirement in 1978. She served as dean of women from 1954 to 1978. The picture at left shows her in her graduation regalia. Below, she is seen many years later at her desk.

Miss Elizabeth T. Newman cared for a flower garden that became known as "Miss Newman's Garden." It was located on the south side of Preston Hall. The picture above shows the fountain surrounded by plants and shrubbery. Nothing remains of the spot that was once one of the loveliest spots on campus. Miss Newman served Belhaven College in several faculty and administrative positions during her 30 years at the college between 1913 and 1943.

Lancaster Hall was built in 1928 as a one-story structure. It was named after Dr. Richard Venable Lancaster, Belhaven's third president. A second floor was added in 1939. The structure was demolished in 1988–89. Note Miss Newman's famous Cherokee roses on the left.

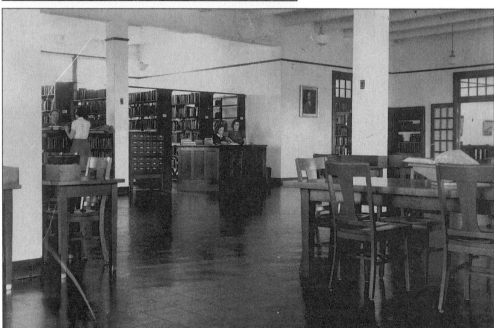

The Elizabeth T. Newman Library was located on the second floor of Lancaster Hall above the dining hall, which was on the first floor. The small and very cramped library with its inadequate holdings was a constant shortcoming pointed out by the Southern Association of Colleges and Schools. With the completion of the Hood Library in 1974, the library in Lancaster Hall was moved to the new facility, which allowed for expanded holdings.

Miss Ethel Depew's piano class of 1929 poses behind what may be the back of the president's home. Students taking piano lessons during the late 1920s paid additional fees. Those who took Miss Depew's class paid an additional $72 per session. Miss Depew is the eighth person from the left (far right) in the back row.

Miss Juliette Chamberlain's piano class of 1922 stands beside a banana plant. Miss Chamberlain is on the far right, the ninth from left. Those registered for graduate hours paid an additional $180. Undergraduate students paid $150. All other piano students paid an additional $90, if taking lessons from Miss Juliette Chamberlain, or $72, if taking lessons from someone other than Miss Chamberlain.

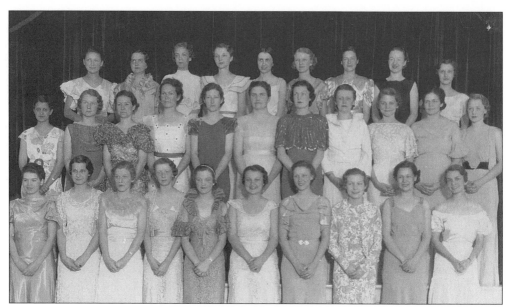

The glee club is posed, ready to sing, in this picture taken in 1933 in Cunningham Chapel. Mrs. Mignonne Caldwell, originator of the Singing Christmas Tree, is standing in the second row, seventh from the left. Belhaven College broadcast regular musical productions during the 1930s over Jackson's radio station, WJDX.

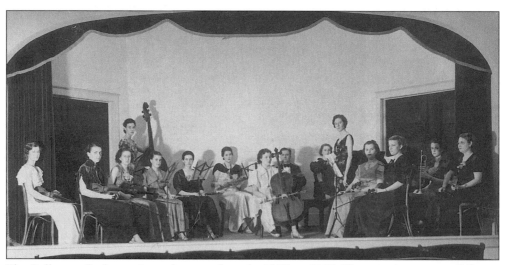

The Belhaven Orchestra is ready to perform in 1937 or 1938. The members are as follows, from left to right: (seated) Elizabeth or Ethel Graves, unidentified, unidentified, Ida Mae Norman, unidentified, Beatrice Youngblood, unidentified, Mr. Fred Powell (faculty), Beverly McLaurin (at piano), unidentified, Mittie Bell Everitt, Nan Barkstrom, and Francis Stringer; (standing) Martha Kennedy and Dosha Dowdy (faculty/conductor).

The graduating class of 1934 appears ready to face a world still in the Great Depression. Although Belhaven College operated in the black during the Depression, in 1934 it was forced to turn to the city of Jackson for financial help. A campaign was undertaken in the summer of 1934 with endorsement by the Chamber of Commerce to raise $10,000 for the coming session.

Members of the 1933–34 Honor Council are seen here in front of the Lagoon, between Fitzhugh and Preston Halls. The Honor Council was what would today be known as the Student Government Association. Fifteen members were chosen by the faculty on the basis of scholarship and deportment. The presidents of the Belhaven Christian Association and the Senior Class were included.

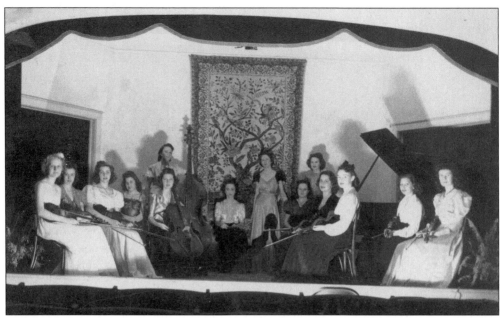

The Belhaven Orchestra performs during the late 1940s in Cunningham Chapel. The young lady seated at the far left in white dress and a flower in her hair is Miss Virginia R. Hooganakker. Miss Hooganakker was a charter member of the Jackson Symphony Orchestra.

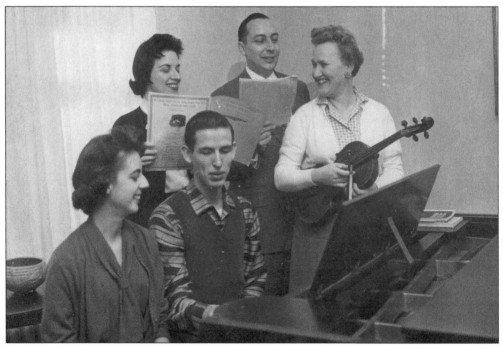

Miss Virginia Hooganakker, with violin, is rehearsing a piece of music during the late 1950s or early 1960s. The sheet music is titled "In a Persian Garden." Miss Hooganakker was a full-time member of the Belhaven music faculty from 1947 to 1986, and then part-time from 1986 to 1998. Two yearbooks, in 1957 and 1986, were dedicated to Miss Hooganakker.

The president's home was located on the campus where the Hood Library now stands. Having the president and his family living on the campus gave the college a family-like atmosphere. In 1974 the house was sold and moved to south Jackson to make room for the new library. This picture was taken in 1959.

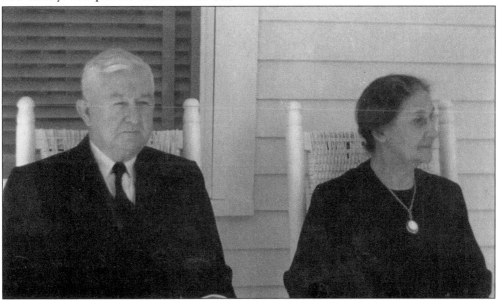

Dr. Guy T. Gillespie spent 33 years as president of Belhaven College. Dr. and Mrs. Lula Tyler Gillespie are seen here in their rocking chairs on the front porch of their campus home. Although not dated, the picture was probably taken near the end of Dr. Gillespie's career at Belhaven College.

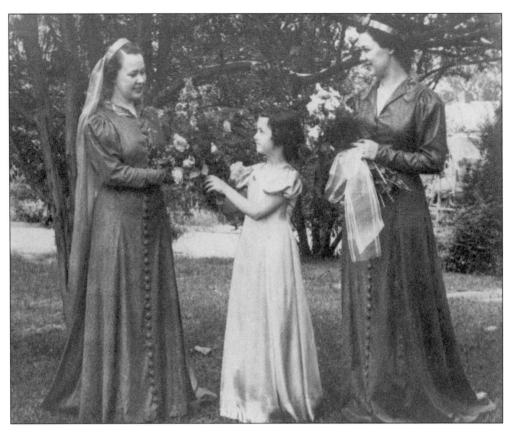

The three daughters of Dr. and Mrs. Gillespie are pictured here dressed for a May Day pageant (date unknown). They are, from left to right, Elizabeth Gillespie Haynes, class of 1938; Virginia Gillespie Brock, class of 1950; and Sara Barry Gillespie Wilson, class of 1935. Both Elizabeth and Sara served on the Belhaven faculty, the former from 1941 to 1949, and the latter between 1938 and 1940.

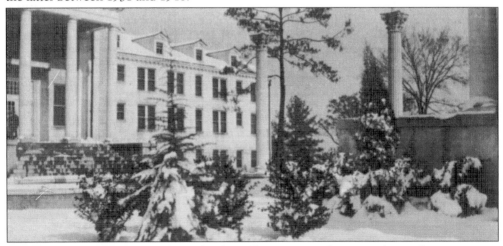

The year of this Christmas card sent by the Gillespies is not known. It bears the inscription: "Merry Christmas from the Gillespies." A snow covered campus was a rare occurrence at Belhaven College, then as it is now.

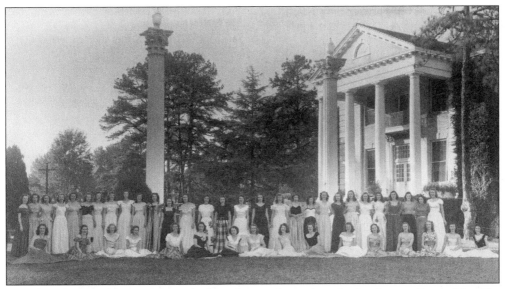

The choral ensemble, "composed of students who enjoy singing," was directed by Mr. Harold Avery when this picture was taken in 1948. The choral ensemble went on a tour of Southern states as far as Florida in 1948. They also performed with the Jackson Symphony Orchestra. They are seen here beside the Lagoon, in front of Fitzhugh Hall.

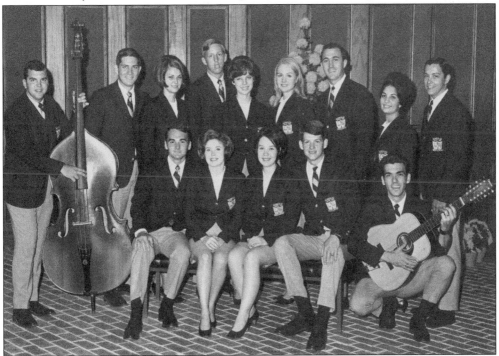

The Highlanders were a popular singing group within the concert choir. The members in 1968 were as follows, from left to right: (seated) Don Cox, Sue Ann Treloar, Betsy Yarborough, John Yarborough, and Barney McCann (kneeling); (standing) Lynn Stringer, Tim Coker, Sandy Schreider, Randy McCoy, Emily Kees, Vicki Lewis, John Rollo, Priscilla Brady, and John Kay.

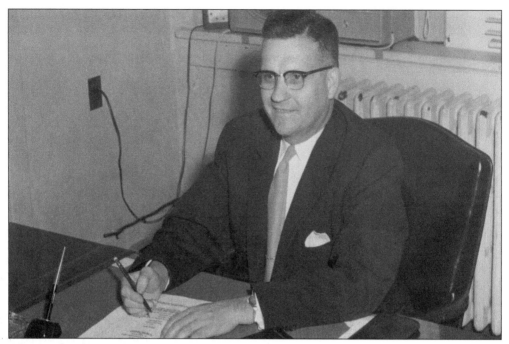

When Dr. Robert McFerran Crowe, pictured here at his desk in 1957, became Belhaven College's sixth president in 1954, the college was facing a crisis. Dr. Crowe undertook a major revision of the school's curriculum to prevent a threatened withdrawal of accreditation by the Southern Association. Under Dr. Crowe, Belhaven became a coeducational college, and in 1957 entered intercollegiate sports.

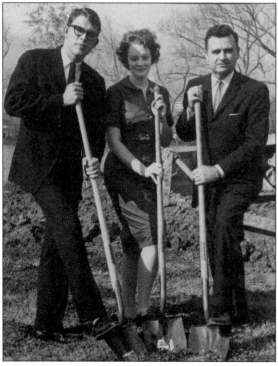

Belhaven undertook a major building program during the administration of President Howard J. Cleland, from 1961 to 1978. Pictured here at the 1963 ground-breaking for the new Heidelberg Gymnasium, from left to right, are I. Newton Wilson, president of the senior class and later president of Belhaven College; Emily Cooper (Haygood), class of 1966; and Dr. Cleland. Miss Cooper was the granddaughter of Dr. Robert F. Cooper, who served as interim president in 1960–61.

Internationally acclaimed author Eudora Welty lived most of her life in the home built by her father just across the street from Belhaven College on Pinehurst Street. Ms. Welty is just one of the many distinguished personalities who have visited Belhaven College over the years.

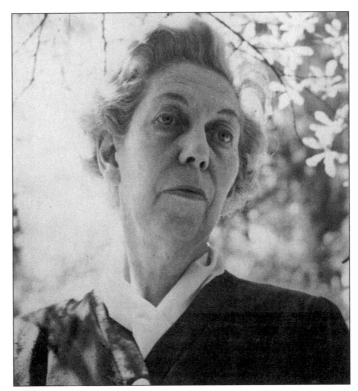

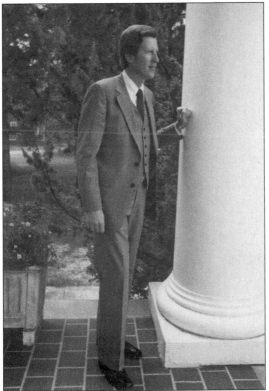

Dr. Verne R. Kennedy, a member of the class of 1963, returned to Belhaven College in 1978 as the college's eighth president. During Dr. Kennedy's tenure, the tennis team won the NAIA national championship (1983), the art department won accreditation by the National Association of Schools of Art and Design (1984), and the Scottish heritage nickname "Clansmen" was changed to "Blazers."

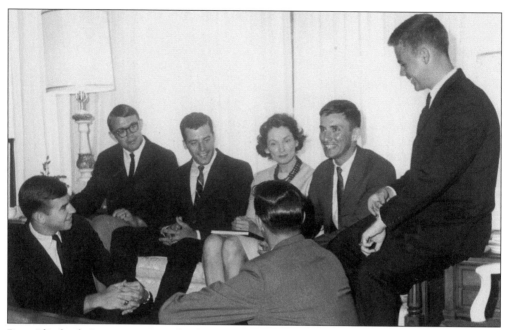

Poet Elizabeth Spencer (Mrs. Elizabeth S. Rusher) was a member of the class of 1942. In 1962, she was chosen as Belhaven's first "Alumnus of the Year." In 1998, the college awarded her an honorary doctorate. Ms. Spencer is seen here with students on a visit to the campus, *c.* 1962. Newton Wilson, class of 1963, is the second from the left.

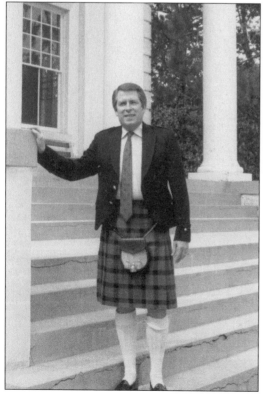

In 1986, Dr. Newton "Newt" Wilson became the ninth president of Belhaven College. Dr. Wilson was "Mr. Belhaven" and president of the senior class in 1963. He served the college as a member of the Bible department faculty, dean of students, director of Christian Ministries, and executive vice president for administration and faculty before being chosen for president of the college. Dr. Wilson is pictured here in a Scottish kilt in front of Preston Hall in 1989.

Three

SPORTS

These tennis players from 1913, are members of Theta Zeta sorority. They are identified on the back of the photograph from left to right as Mattyle Turner, Vivien Bernard, Alma Rea, Lowell "Bunny" Sedgewich, Helen Weilerman, Gladys Johnson, and Irma Provine. Sororities were popular at Belhaven College until 1932, when they were abolished.

Members of the 1916 YWCA Cabinet are pictured in the sitting room set aside for the organization. The YWCA was organized on the Belhaven campus in 1911. It offered daily prayer meetings for the students, as well as other activities to enrich the social, intellectual, and spiritual lives of the students.

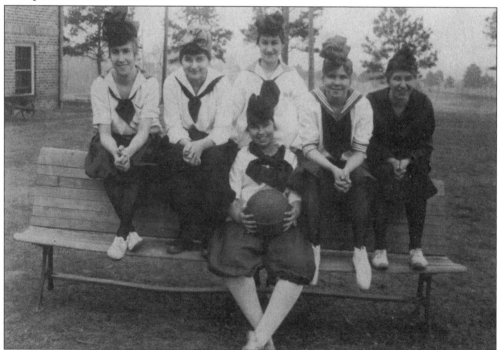

Members of Basketball Team II in 1916 pose on a bench outside the college. Mary Gladys Hoover served as team captain and guard. The early yearbooks often list the names of team members, but do not indicate who they are in the pictures. Members were Mary Gladys Hoover, Winnefred Kelly, Annie Holleman, Kate Lewis, Hazel Gorden, and Aileen Gary.

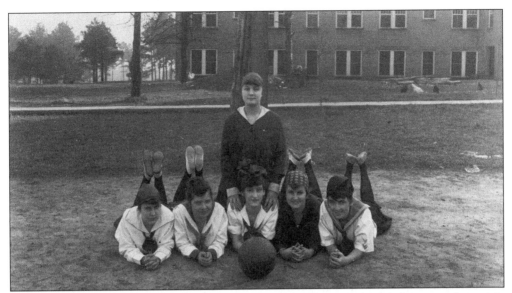

Basketball Team I from 1916, included (exact order unknown) Victoria Lampton (captain), Natalie Guthrie, Susie Dampeer, Ruby Legan, Alma Caldwell, and Inez McDougald. Sport teams at Belhaven College in the early days played each other, church teams, and public high school teams in the area. Notice the chickens grazing in the background around the college.

Members of Basketball Team IV in 1916 included (exact order not known) Gertrude Weston, Laura May Hairston, Laura Newman (captain), Stella McCraine, Ina May Newton, and Lillian Carr. Basketball was the only intercollegiate sport at Belhaven College. They played Millsaps, Hillman, Grenada, Mississippi Women's College, and State Teacher's College. Intercollegiate sports were abolished in 1936, and not reintroduced until 20 years later.

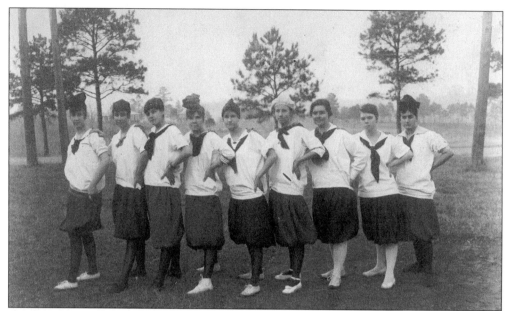

The required uniform for sports teams was "a white middy blouse, black bloomers and white tennis shoes." In 1927, this uniform could be purchased at the college book store for $5. In this photograph the members of the 1916 baseball team are seen wearing the required uniform, minus the white tennis shoes. Perhaps only in headgear and shoes were these girls able to show some individuality.

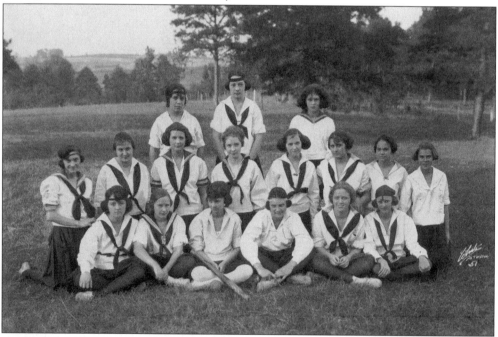

Members of this 1922 baseball team are shown wearing the required white tennis shoes. The *Aurora* of that year lists 32 players. The Belhaven Athletic Association of 1922 represented five sports—basketball, tennis, baseball, swimming, and volleyball. Miss Louise E. Alteneder, a Bible teacher, served as athletic director for the college.

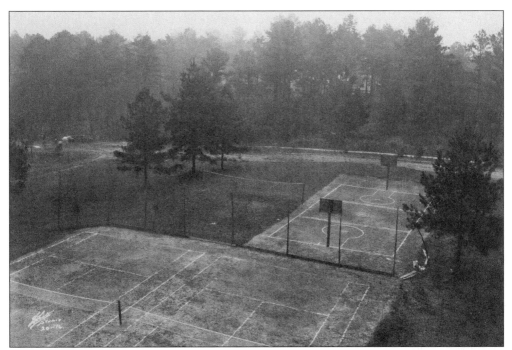

The old tennis, basketball, and volleyball courts are seen in the late 1920s. This area appears to be where Irby Hall is today. If so, the dirt road in the background would be Pinehurst Street. Note the farm workers with mules or horses in the field at left. These courts were replaced in 1958.

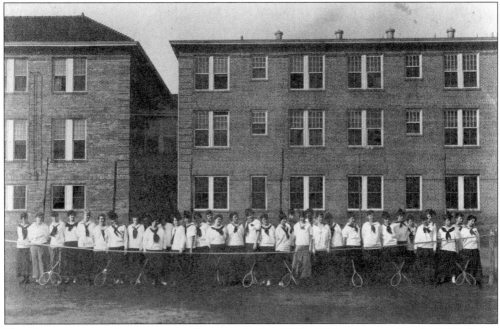

Tennis was apparently a very popular sport in the 1920s. This picture taken in 1922 shows 35 players; one may be a faculty member. The 1922 *Aurora* lists 41 who participated in tennis during that year.

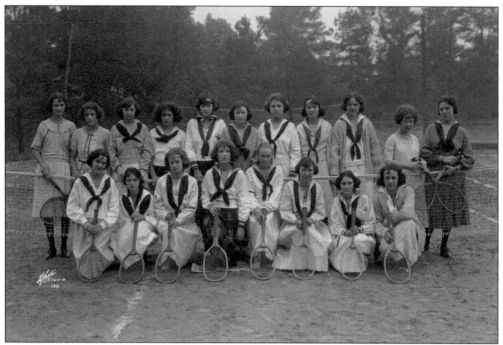

A group of tennis players from 1922 are pictured on the courts. Helen Holaday won the tennis singles in the Belhaven tennis tournament of that year. Frances Harrington and Helen Wallace won the doubles.

This scene of ladies playing tennis on the old courts in the 1940s does not seem to be a serious match. Pinehurst Street in the background has changed a lot since the picture on p. 73. The house on the left is still standing.

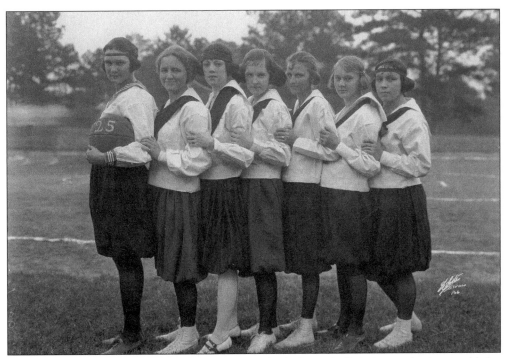

Pictured here is the freshmen (class of 1925) basketball team of 1922. Members were (order unknown) Katherine Bingham, Irene Caldwell, Mary Belle Elliott, Irene Hutcheson, Mary Hunt Plummer, O.B. Turner, and Frances Harrington.

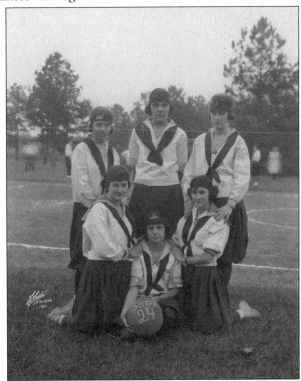

Pictured here is the sophomore (class of 1924) basketball team of 1922. Members were (order unknown) Hilda Alexander, Cloe Lowery, Maurine McInnis, Blanche Melvin, Mattie Townes, and Helen Wallace.

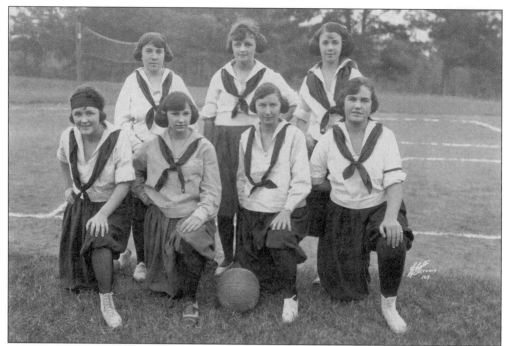

Members of the senior-junior basketball team of 1922 are pictured here beside the basketball court. Members were (order unknown) Mildred Fairley, Georgine Flanders, Rie Jarratt, Eva Mixon, Lulu Williams, Elizabeth Wilkins, and Maud McLaurin.

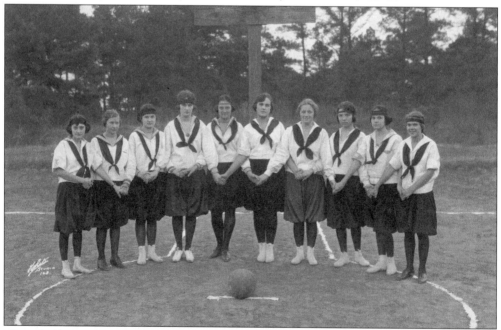

These ladies were members of the "all college," or varsity basketball team of 1922. They are (order unknown) Hilda Alexander, Irene Caldwell, Cloe Lowery, Maurine McInnis, Helen Wallace, Mary Hunt Plummer, Hazel Pratt, Elizabeth Stewart, Mattie Townes, and Lulu Williams.

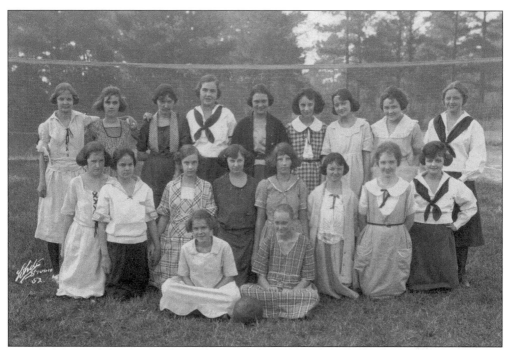

Twenty-five students were listed in the 1922 *Aurora* on the "Volley Ball Roll." Many of the names appear as members of other sports teams. This is understandable in light of the fact that all students at Belhaven College were required to be enrolled in a class of physical culture, that is, sports.

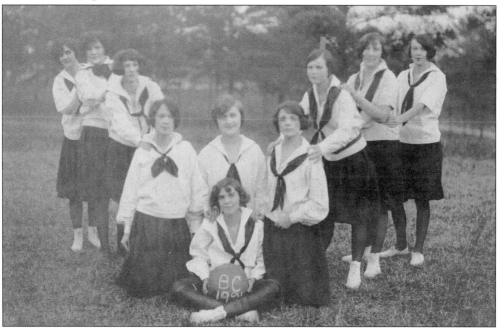

These members of a volleyball team in 1926 appear to be holding a basketball, but are identified as a volleyball team. There were 163 students enrolled as regular students, and an additional 97 students enrolled as special students in music and art, in 1927.

The track team of 1926 poses along Pinehurst Street on the south side of Preston Hall. The home of the internationally known author Eudora Welty is in the background. According to the 1927 college catalog: "The physical welfare of students entrusted to our care is regarded by us as a matter of first importance. . . . Regular physical exercise is required of all students under the supervision of a capable director."

Students in regulation gym clothes are pictured here on a hike in the late 1920s; the location is not known. The college being located "in the midst of the native pines, on an ample campus, sufficiently remote to escape the smoke and dust of the city," provided many opportunities for hikes in the fresh air.

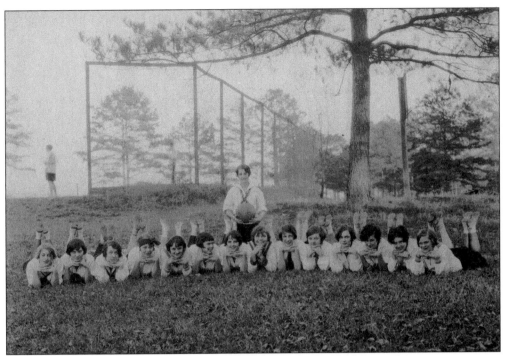

A group of students identified as a basketball team are shown beside the tennis and basketball courts. The location is in the area currently occupied by Irby Hall.

A basketball team of 1929–30 is pictured in front of the Lagoon and in front of Fitzhugh Hall. Notice that just two years after the previous picture the gym uniform appears to have changed somewhat; however, since they are not holding a basketball, perhaps they are not dressed to play.

These girls standing on what appears to be a pile of 4-by-4 timbers are identified as a "gymnasium class." Belhaven College did not have an indoor gym in the late 1920s, when this picture was taken. A gym field class performed in an open "gym field," behind what are today Preston and Fitzhugh Halls. Old pictures of the basketball and tennis courts seem to indicate that during the early years they were located on the south side of what is today Preston Hall, but later, sometime after 1927, moved to the area now occupied by Irby Hall. Some pictures (for example the one on top of p. 78) clearly place the location of the courts on the south side of Preston Hall. The picture on the bottom of p. 74 was taken where Irby Hall presently stands.

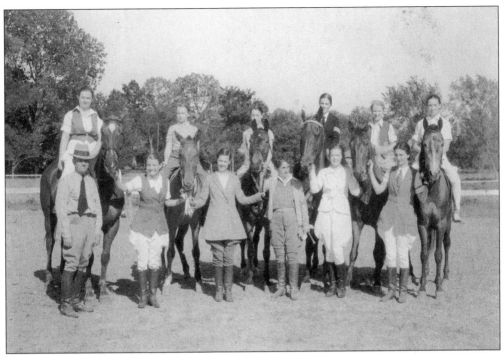

Horseback riding was a popular sport at Belhaven College during the 1930s and 1940s. In these two pictures the Equitation Club of 1933 (above) and 1936 or 1937 (below) are pictured with Col. Fred Powell, the instructor in horseback riding. In 1933, students were required to take three hours of physical education per week. Equitation was offered as an elective under "Physical Education 101-102." Students enrolled in this class had one hour per week of "formal gymnastic exercise," and two hours per week of an elective sport. Swimming, hiking, basketball, equitation, and "games" were offered as electives during the winter. Colonel Powell served on the faculty between 1932 and 1952.

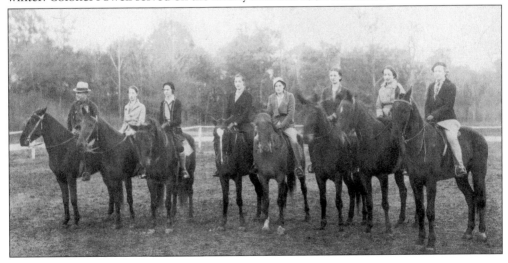

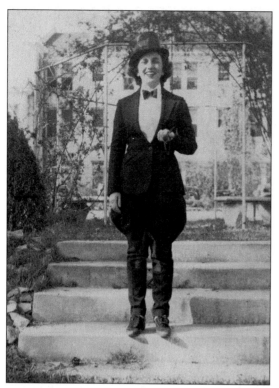

The two photographs shown here indicate that horseback riding was for some of the students more than just a means of meeting the physical education requirement. The student in this picture (from a student scrapbook of 1938–39) seems to approach horseback riding as the leisurely activity of the old Southern gentry. Her admiring classmates are undoubtedly as impressed with the horse as they are with their friend's skill.

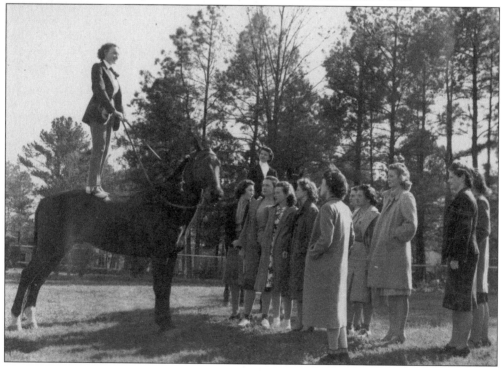

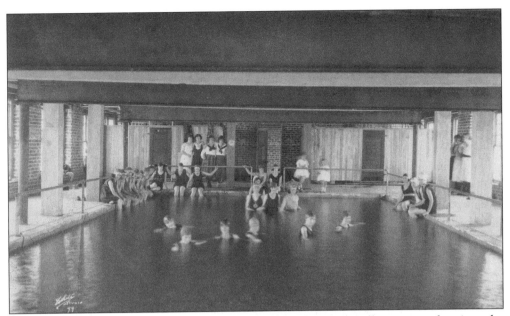

The first swimming pool was on the ground floor of Fitzhugh Hall; it was sunken into the floor. Later, faculty offices and a computer lab were located in this area. The faculty for the math department currently occupy offices where once students swam.

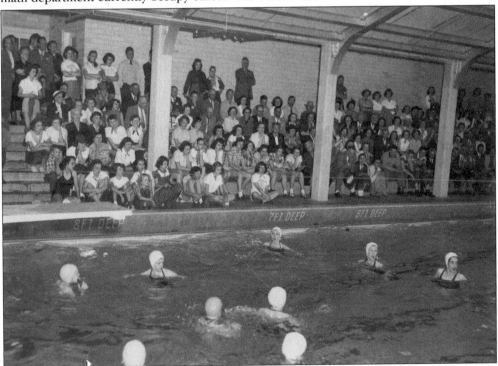

The Recreation Building was constructed in 1949 as a gift of Mr. Robert D. Sanders and it housed a gymnasium. Behind the Recreation Building, in a separate building, was the new swimming pool. In this photograph from the 1950s, a water ballet class is performing. The college has not had a swimming pool since *c*. 1990.

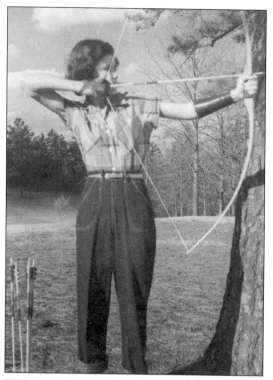

Archery was a popular sport at Belhaven College. During the 1930s, it was listed as a spring and fall elective in physical education 101-102. Here Miss Lanelle Hill, a freshman in 1952, is pictured enjoying the sport, and doing rather well, as we can see from the target. Apparently the campus was still "rural" enough in the early 1950s that one could practice archery without fear of injuring someone living along the edge of the campus.

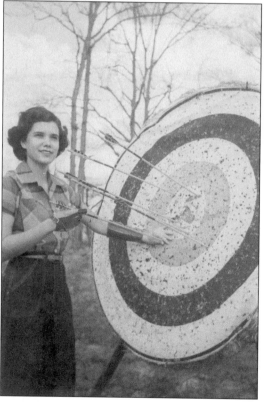

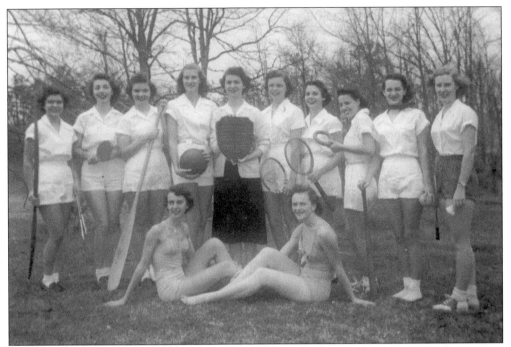

A group of students is pictured here with symbols of sports played at Belhaven College during the 1950s. They included archery, ping pong, canoeing, tennis, horseback riding, softball, badminton, and swimming. The ring held by one of the students was used in a horseback riding sport called the "doughnut race."

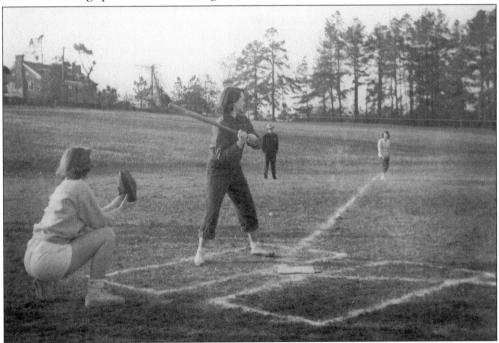

Students played softball in the Bowl, and today, softball is an intercollegiate sport. Scholarships are offered today to athletes who play softball, as well as other varsity sports.

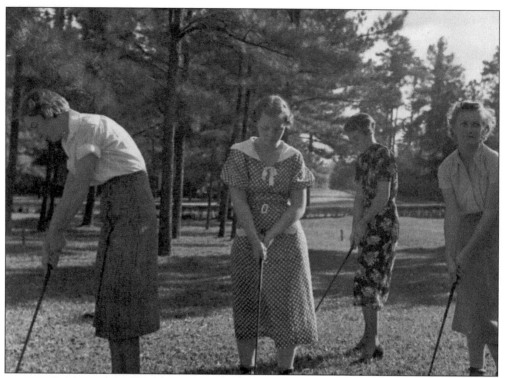

Although golf is not one of the sports shown in the photograph at the top of p. 85, it was not unknown at Belhaven College. Here we see, from left to right, Sarah Hunt Baskerville, Edith Turpin, Mary Elizabeth Thompson, and (possibly) Nan Kirk practicing their stance.

Hermine Boteler (left), a member of the class of 1962, and Mrs. Anne Gookin (physical education teacher) are "Golf Champs" in this photograph from 1959. The Recreation Building (the current Fine Arts Building) is in the background.

Opposing tennis teams shake hands before a match in 1957. The two women on the left have not been identified, and may have been from another college. The two on the right are, from left to right, Sylvia Howell (class of 1959) and Glinda Smith (also class of 1959).

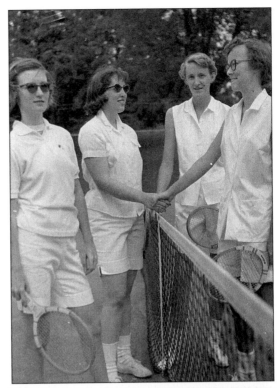

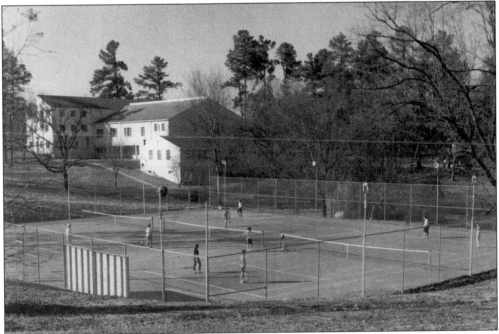

The tennis courts were moved to their present location behind the Recreation Building when Irby Hall was constructed in 1963. The Recreation Building was renovated and renamed the Fine Arts Building in 1963, when Heidelberg Gymnasium was constructed. In 2000, this area was designated as the future site of a new Fine Arts Building.

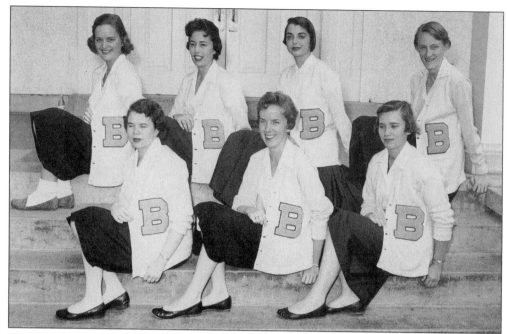

Women who participated in varsity sports were members of the "B Club." Members of the 1957 "B Girls" were as follows, from left to right: (bottom row) Julia Crittenden, Anna McAuley, and Betty Ann McClendon; (top row) Marideth Wall, Dolores Overstreet, Lucy Granthem, and Sylvia Howell.

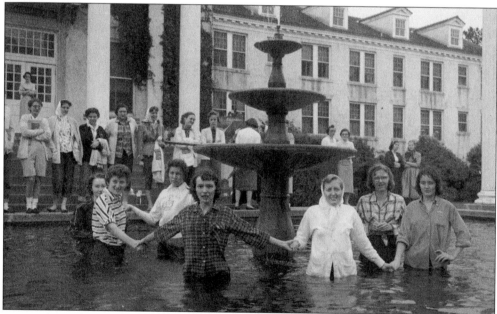

New initiates into the B Club were put in the Lagoon early in the morning. Pictured here are the new initiates of 1957. They are, from left to right, Betty H. Quinn, Ann Lane, Florence Richardson, Nancy Mangum, Nita Majure, Peggy Jo Bell, and Carrell Watkins. Betty Quinn joined the faculty in 1966. Still serving full-time in 2000–2001, Ms. Quinn is one of the most beloved members of Belhaven's alumni and faculty.

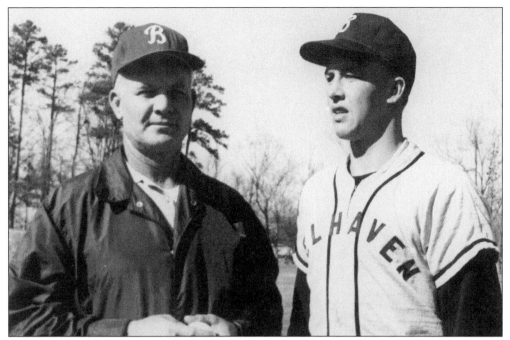

James McLoed (left) served as a coach at Belhaven College between 1955 and 1978. He is pictured here with a baseball player (identity unknown) during the 1970s. Coach McLoed was one of the first inductees into the Belhaven Sports Hall of Fame, established in 1993.

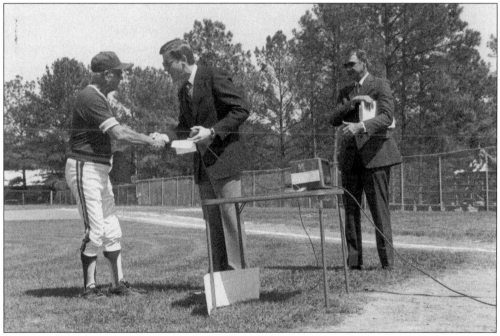

In 1996, property along Riverside Drive was acquired as an athletic field and was dedicated as "McLoed Field" in honor of Coach James McLoed. Pictured here at the dedication, from left to right, are Coach McLoed, Dr. Verne R. Kennedy, and Coach Charles Rugg. Coach Rugg was inducted into the NAIA National Tennis Hall of Fame in 1996.

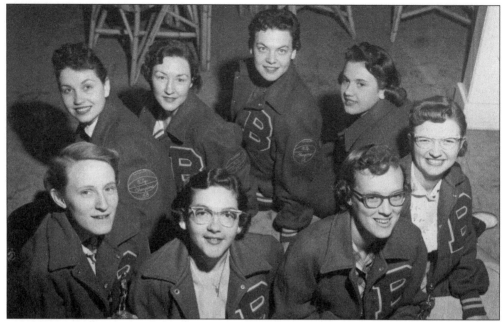

The women's basketball team won the city championship in 1958. Pictured are the following, from left to right: (bottom row) Sylvia Howell (who was later inducted into the Mississippi Sports Hall of Fame), Annette Vaughn, Glinda Smith, and Jackie Goertz; (back row) Treasure Lee, Carolyn Gallent, and Danny Lowry. Intercollegiate women's basketball was introduced in 1972 under coach Gwen White.

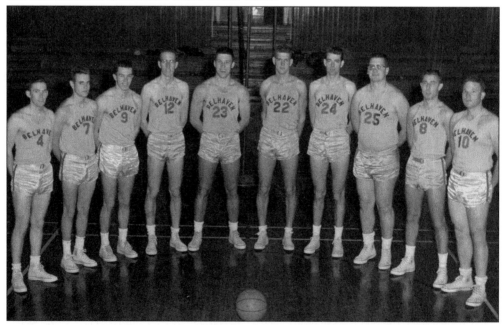

After Belhaven College became coeducational in 1954, men's varsity sports became an increasingly important part of student life. The members of the 1959 men's basketball team are, from left to right, Larry Mills, Tom Donovan, Greg Townley, Arnold Lotz, James Scott, Sonny Whitlock, Eral Graham, Rogers Gallion, Richard Aeschliman, and Don Gahagen.

90

Coach Charles R. Rugg (center) joined the Belhaven faculty in 1963. In addition to coaching, he served as athletic director and associate professor of history. Under Coach Rugg's expertise, the men's basketball team achieved regional and national attention. Mr. Rugg retired in 1998, after 35 years service to the college.

Heidelberg Gymnasium was constructed in 1963 in honor of Roy L. Heidelberg, a Jackson businessman and philanthropist. It was renovated in 1999, adding a new dance studio and weight, training, and locker rooms.

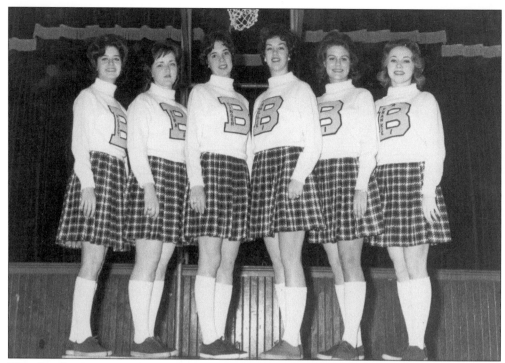

The cheerleaders contributed to school spirit through their participation at varsity games. The 1962 cheerleaders were, from left to right, Peggy Mood, Elma Calhoun, Ginger Bell, Hallie Spackman, Loren Ormond, and Frankie McCormick.

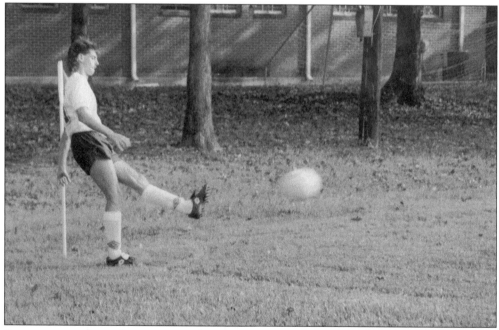

Soccer was perhaps the most popular varsity sport before the introduction of football in 1997. The team won the 1992 NAIA national championship under Peter Fuller's coaching. Sean Bushey, class of 1990, is pictured in this action shot.

Four

CAMPUS LIFE

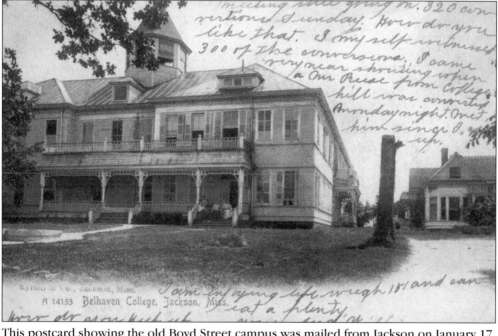

This postcard showing the old Boyd Street campus was mailed from Jackson on January 17, 1907. The handwritten note reads: "Meeting still going on. 320 conversions Sunday. How do you like that? I myself witnessed 300 of the conversions. I came very near shouting, when a Mr. Ruse [or Buse] from College Hill was converted Sunday night. Met him since I came up. I am enjoying life, weigh 151 and can eat a plenty. How do you keep up? Your Bud, Will." Whether the revival referred to was on the campus or in Jackson is not clear. If there was a revivalist in town, students from Belhaven College undoubtedly attended.

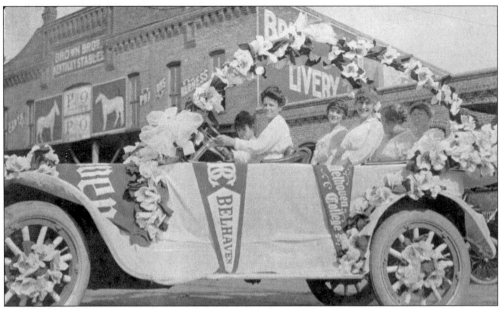

The senior class of 1916 won first place in the automobile parade at the Mississippi State Fair in the fall of 1915. The location of the picture is probably somewhere along State Street, in front of Brown Brothers' Kentucky Stables.

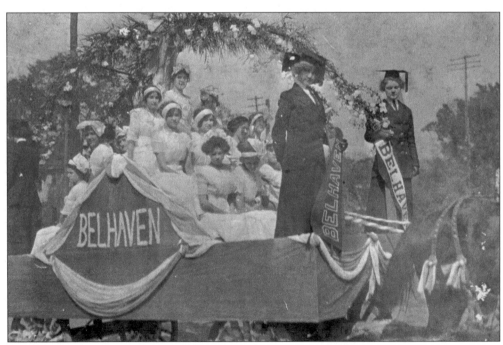

Another Belhaven student float is pictured on a postcard. The date is not known, but it may be from the 1910s or early 1920s. The float is drawn by horses.

A group of students from Miss Mary Forman's voice class of 1916 are pictured here as they appear in the 1916 *Aurora*. They are seated in the original building of the Belhaven Collegiate and Industrial Institute.

Members of the French Club are pictured here as they appear in the 1916 *Aurora*, with the president's home in the background. The club's officers in 1916 were Eunice Holleman (president), Bessie Ford (vice president), and Kate Lewis (secretary-treasurer). The club's motto was "*Vouloir c'est Pouvoir.*"

The three young ladies pictured here in front of the college are, from left to right, Leah Fore, Elizabeth Kling, and Helen Newcomer. In the 1921–22 college catalog, Leah Fore is listed as an "Irregular" student, and both Elizabeth Kling and Helen Newcomer are listed as "Preparatory" students. Irregular students were those who were not pursuing a degree. Preparatory students were admitted to the Belhaven Preparatory School. They were granted certificates on completion of 15 units.

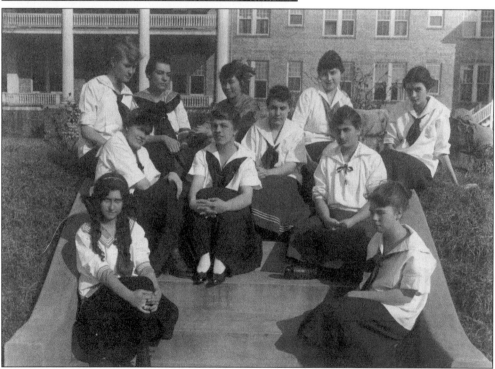

A group of students in uniforms sit on the steps facing Peachtree Street. The identity of the students is not known, nor is the exact date. Perhaps it is a club during the 1920s.

96

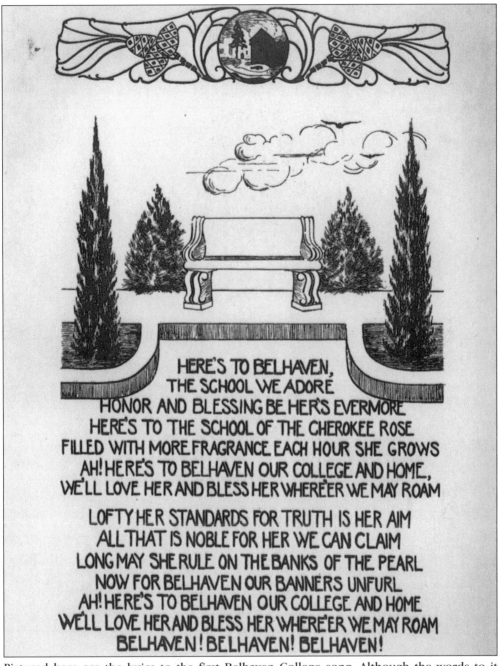

HERE'S TO BELHAVEN,
THE SCHOOL WE ADORE
HONOR AND BLESSING BE HER'S EVERMORE
HERE'S TO THE SCHOOL OF THE CHEROKEE ROSE
FILLED WITH MORE FRAGRANCE EACH HOUR SHE GROWS
AH! HERE'S TO BELHAVEN OUR COLLEGE AND HOME,
WE'LL LOVE HER AND BLESS HER WHERE'ER WE MAY ROAM

LOFTY HER STANDARDS FOR TRUTH IS HER AIM
ALL THAT IS NOBLE FOR HER WE CAN CLAIM
LONG MAY SHE RULE ON THE BANKS OF THE PEARL
NOW FOR BELHAVEN OUR BANNERS UNFURL
AH! HERE'S TO BELHAVEN OUR COLLEGE AND HOME
WE'LL LOVE HER AND BLESS HER WHERE'ER WE MAY ROAM
BELHAVEN! BELHAVEN! BELHAVEN!

Pictured here are the lyrics to the first Belhaven College song. Although the words to it appear in numerous places, there is no known copy of the music for it. This song was apparently difficult to sing, and not greatly loved by students. In 1940, a new Alma Mater was written by a group of students in Miss Dosha Dowdy's music composition class. The new Belhaven Alma Mater (see p. 117) was still not universally accepted. In the 1960s, another song beginning with the words, "Belhaven, may you long remain a stalwart stronghold for the right," appeared as a possible rival. It was not successful, however, and the Belhaven Alma Mater of 1940 remains the school song into the 21st century.

A group of students are acting out some sort of play or pageant around a fountain, located perhaps on the south side of Preston Hall. Note the farm building in the background. The date is not certain, but it was most likely in 1929.

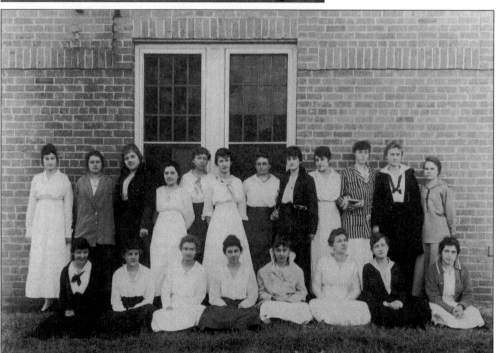

Miss Elizabeth T. Newman is the seventh person from the left in the back row of this group of students, seen beside the original building during the mid-1920s. Perhaps it is one of Miss Newman's English classes.

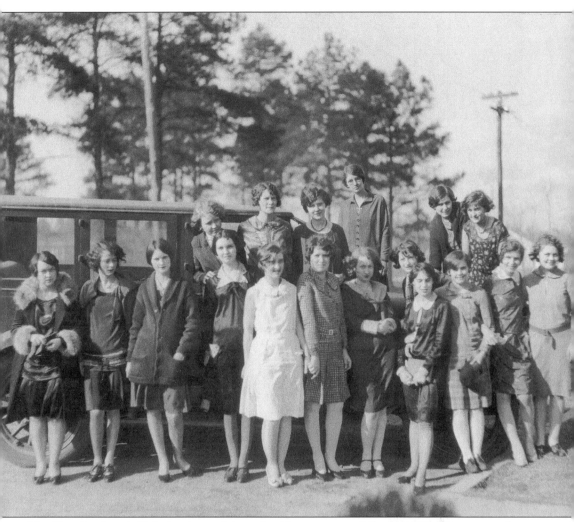

The Day Students' Club is pictured here beside an automobile in 1928. They were also known as the "Jackson Belles," and had as their motto, "Keep the City Belles Ringing." Their pose in front of an automobile calls attention to Regulation Number 2 in the 1928 college catalog: "Students are not allowed to ride in an automobile with young men, without special permission. The violation of this rule will bring upon the offenders the severest penalty of the College." Students could receive visits from young men only with the written permission of their parents. No visitors were permitted during school hours or on the "Sabbath day." Belhaven College was, according to its catalog, "above all else a school of Character."

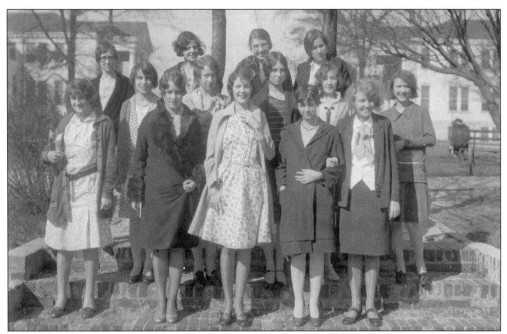

The Jackson Belles Club of 1929 pose on steps facing east toward what is now the Bailey Student Center. Students living with parents or boarding in private residences "was not always desirable," according to the 1934 catalog. "Only in exceptional cases will such an arrangement be approved by the college authorities, and then only after personal investigation of all the facts in the case."

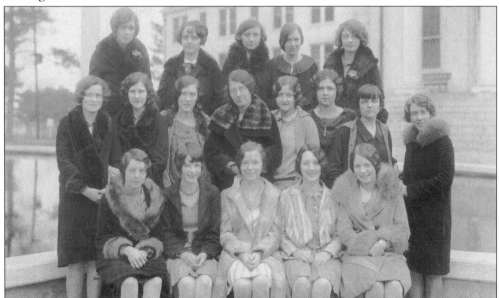

The Education Club of 1929, later known as the Preston Education Club, had as its purpose "the stimulation of professional interest among those juniors and seniors who expect to teach." Leading men and women in Mississippi education were frequent guests at monthly social meetings. The lady in the black coat with fur collar, standing alone at extreme right end of the second row, is Miss Bess Caldwell.

The gentleman pictured here in front of Fitzhugh Hall is identified as Mr. Erasmus "Raz" Mansell, the Belhaven College bus driver. There is no other information available about Mr. Mansell. Perhaps he was not actually an employee of the college, but rather the driver of a charter bus.

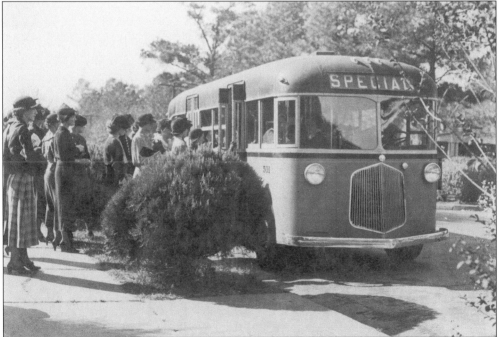

The students pictured here are boarding a Jackson streetcar, presumably for a trip into the city. Regulations were being relaxed somewhat by the mid-1930s. Groups of students were allowed to visit the city on Saturdays, and the ban on automobile riding with young men was modified to allow such, "with special permission and with a chaperon approved by the college hostess."

Eight members of Miss Adele McNair's class in sight reading gather on the steps of the front porch in 1922. Sight reading was a class offered to piano students. Miss McNair taught violin, mandolin, and sight reading.

A student room in Preston Hall, probably during the 1930s, is pictured here. Preston Hall at that time housed administrative offices, Cunningham Chapel, classrooms, conservatory studios, science laboratories, dormitory rooms, the local students' club room, and the college book store. To walk through it today, it is hard to imagine how it was possible. Today, Preston Hall houses administrative, business, and faculty offices.

102

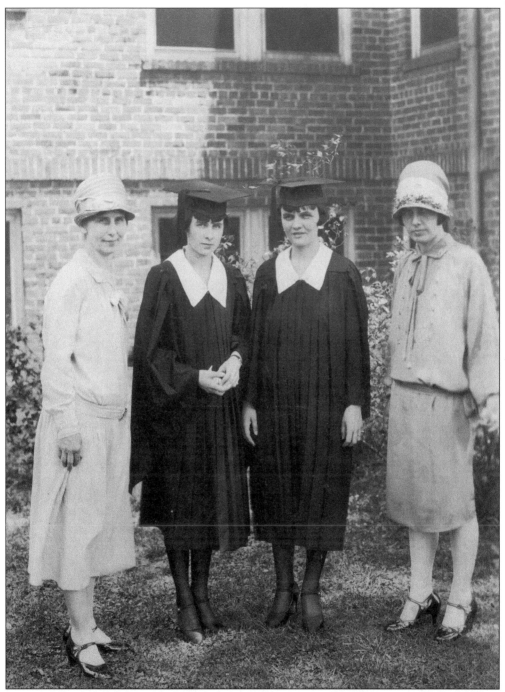

Often whole families attended Belhaven College. The four Lewis sisters pictured on p. 43, and the Shields family pictured here at the graduation of the two sisters in 1927, are examples. Pictured here from left to right are Mrs. Shields (mother), Ruth (class of 1927), Margaret (class of 1927) , and Miriam (class of 1924). Margaret Shields joined the faculty of the college in 1941, and taught modern languages and literature until 1971. A number of Belhaven's longest serving faculty and staff members were graduates of the college.

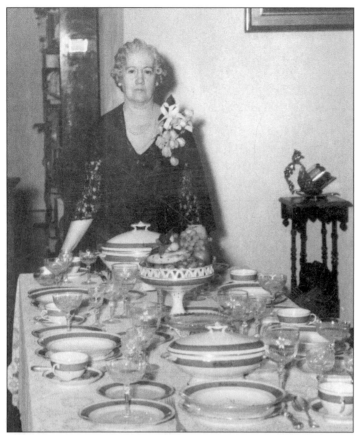

Miss Annie Sale, who taught household arts and home economics between 1929 and 1953, is pictured here with the "Belhaven China." A student is shown below with the "Belhaven Silver Set." Neither the china nor the silver actually belong to the college. They belonged to the family of Col. Jones Hamilton, who sold his residence, "Belhaven," on Boyd Street to Dr. Louis T. Fitzhugh in 1894 as a home for the new college. They were both used on special occasions over the years. Today, the silver set is on display in the Heritage Room of the Hood Library, and the china is in the possession of the heirs of Colonel Hamilton.

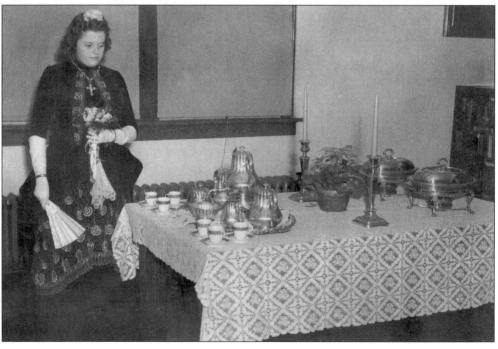

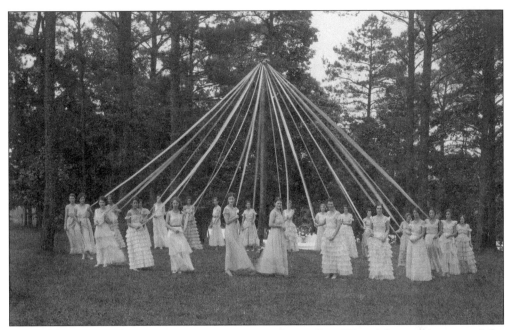

The May Day Festival was a major campus event during Dr. Gillespie's presidency, and the first record of a May Day festival was in 1929. Above is the senior May Pole dance being performed down by the lake in 1932. Below, what appears to be the senior class of 1932 is gathered behind a garland of flowers (perhaps Magnolia blossoms). They are on the west side of Preston Hall. Miss Eudora Welty's house is visible in the background.

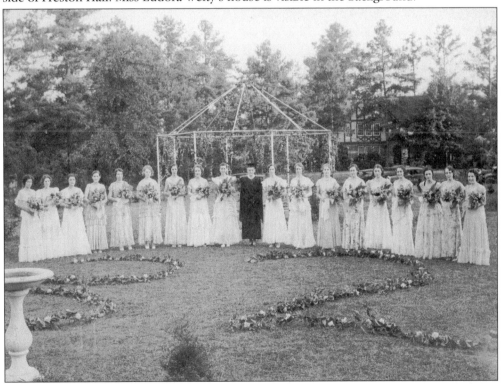

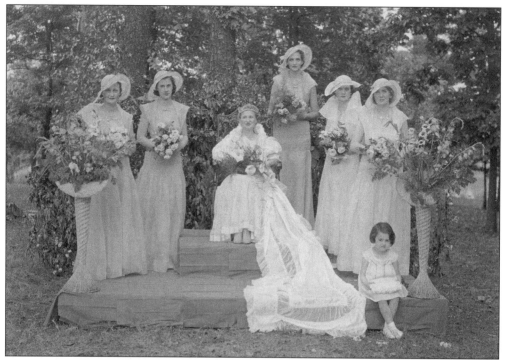

Two more scenes from the 1932 May Day festival are pictured here. Above is the May Day Queen (identity unknown) and her court. The little girl is Virginia Gillespie, daughter of Dr. and Mrs. Gillespie. Virginia Gillespie (Mrs. Virginia Brock) graduated from Belhaven College in 1950. Below is the class of 1932 at the May Day festival. Both pictures appear to have the college lake in the background.

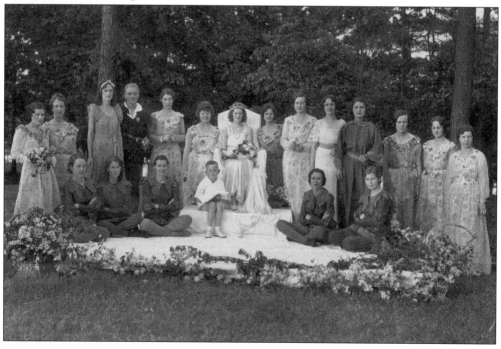

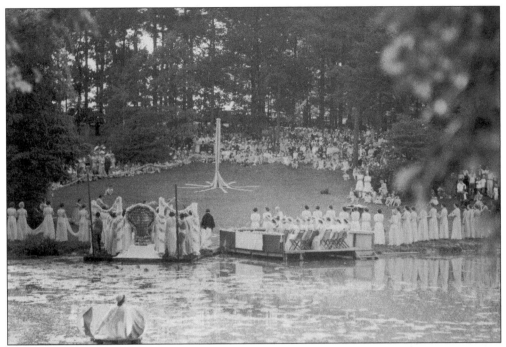

The May Day festival in 1936 was held down by the college lake. Above, "the court and all the symbolic dancers as well as the vast assemblage of visitors" are waiting for the traditional May Pole dance to begin. Below, three students are performing the hoop dance in front of the May Queen and her court. From left to right are Annie Mae Bruson, Laurene Hurst, and Martha Jane Boyd.

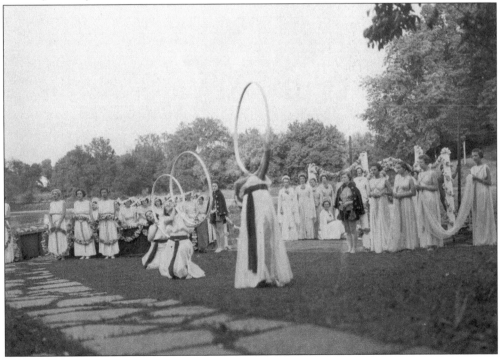

Miss Bessie Cary Lemly, art teacher from 1915 to 1943, was Belhaven's "Queen of Yesterday" during a May Day festival (year unknown). She is seated on a bench on the south side of Preston Hall, with Eudora Welty's home in the background. During the academic year 1916–17, when Belhaven was without a president, Miss Lemly directed the business affairs of the college. An art gallery in Hood Library was opened and named in her honor in 1997.

Mary Georgie Watkins (Mrs. Paul W. McMullan) was May Queen in 1952. The May Day festivals were discontinued in the mid-1950s. As the school became coeducational in 1954, and intercollegiate sports were reintroduced in 1957, the whole atmosphere on campus was rapidly changing. Family style dining gave way to the cafeteria in 1958, and commuter students were becoming an ever larger part of the student population.

The graduating class of 1933 included 20 B.S. degrees, four B.M. (bachelor of music) degrees, and three B.A. degrees. The college dropped both the B.S. and B.M. degrees in 1947, just one year after gaining accreditation by the Southern Association of Colleges and Schools. Dr. Gillespie had recommended this change 20 years earlier. The B.M. degree was reinstated in 1948, but the B.S. degree was not reinstated until 1964.

Emily Velsansky graduated from Belhaven College in 1934, when the college, like the rest of the nation, was in the depths of the Great Depression. The Depression brought financial hardship to the college. In February 1933, Dr. Gillespie reported that the Synod of Mississippi, which had pledged $10,000 annual support for the college, had given only $377.38 since June 1, 1932.

109

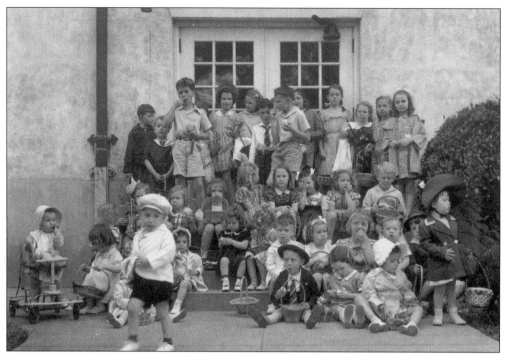

An annual event, the Easter egg hunt for children of alumni, was begun on April 13, 1934. Hundreds of eggs were hard boiled and decorated, then hidden on the campus around Preston and Fitzhugh Halls. The children pictured above from 1938 or 1939 are enjoying the fruits of their labors.

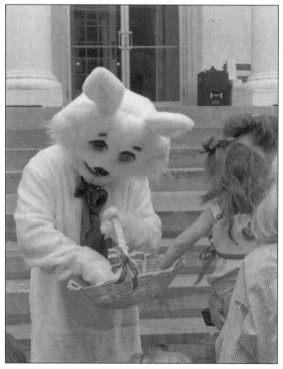

By the 1990s, the Easter egg hunt was well attended by children of the neighborhood, as well as those from alumni, faculty, and staff families. An Easter Bunny, often Dr. William "Bill" Penn, economics professor, added to the children's excitement.

The Belhaven Christian Association was a voluntary student organization that helped the college fulfill its mission as a Christian college. The members of the BCA in 1969 are as follows, from left to right: Dr. Norman Harper (faculty), John Reeves, Jim Ostenson, Billy Tyson, Hank Griffith, Sherron George, Brenda Hoover, Sandra Schreiter, Charlott Graham, and David McArthur. Many of the students who were active in the BCA went on to serve as pastors, missionaries, faculty, and even presidents of Christian colleges, and in many other areas of Christian ministry. The BCA no longer exists—it was superceded by the Reformed University Fellowship, Baptist Student Union, and other student fellowships that represent the denominational diversity of today's student body. Although Belhaven College is a conservative evangelical Christian college, it has never attempted to force a particular denominational identity on its students. Even Roman Catholic students who attend Belhaven are free to meet together for Christian fellowship, and invite speakers to address their group.

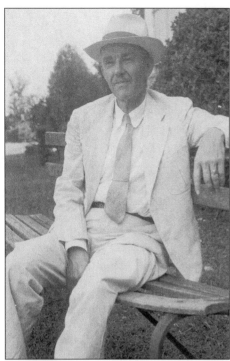

Dr. Colley Sparkman taught French and Spanish in the foreign languages department from 1934 to 1964. French, Spanish, and Latin were offered in 1934. In 1936, Dr. Sparkman and Dr. Dorothy McCoy in mathematics were the only two faculty members with Ph.D.s. In 1954, when Dr. Robert McFerran Crowe became president, there were only 4 out of 26 faculty members with terminal degrees.

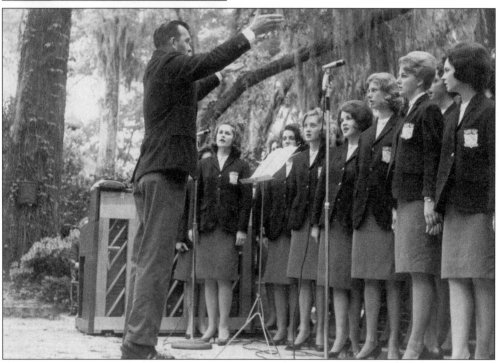

Mr. Henry T. Ford is pictured here directing the Belhaven Concert Choir during the 1960s. Mr. Ford took the concert choir on tour to Europe during 1972. Under his direction, men were added to the annual Singing Christmas Tree, and in 1963, the performance was moved from the Lagoon to the Bowl.

The Sextette was a group of six singers who performed in churches and wherever invited to do so. Members of the 1934–35 Sextette, from left to right, were Ruth Giles, Almeta Reeves, Mary Louise Irvine, Mignonne Caldwell, Dorothy Dell Downing, and Marjorie Quinn.

The Sextette was still singing in 1959. The members shown here are as follows, from left to right: (front row) Penny Zeller, Martha Sumrall, and Alyce Cutrer; (back row) Jane Harris, Betty Chamblin, Joan Mendom, and Lee Sens.

Drama continued to be a part of campus life. Seen here are members of the cast of *Oklahoma*, staged by students around 1958. From left to right are Margaret Holloway, Sandra Billups, and Joyce Wallace. In 1999, a new major in theatre was added to the curriculum under the direction of Dr. Louis H. Campbell.

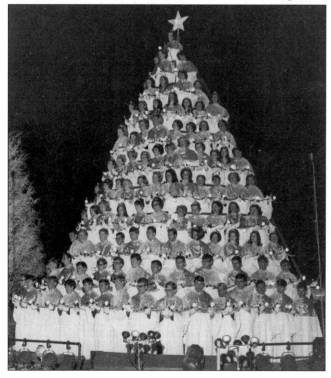

Due to the ever increasing crowds that came to see the annual Singing Christmas Tree, the performance was moved to the Bowl in 1963. Men were added in 1962. The performance pictured here is from 1969. The performance always concludes with a senior voice student singing "O Holy Night."

Play Day was originally organized in 1933 by Mrs. Hilda Alexander Powell, wife of Col. Fred Powell. It soon became an annual event that continued into the mid-1950s. Students competed with one another in a variety of sports. Mary Grace Clark (left) and possibly Virginia Rimmer (right) competed in archery during Play Day in 1937.

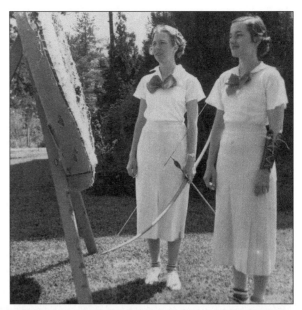

Freshman Day provided upperclassmen an opportunity to initiate freshmen into the Belhaven family. Upperclassman Tom Maynor (class of 1961) is pictured here during Freshmen Day in 1959, wielding the clippers on three freshmen. Two other upperclassmen look on.

Students at today's Belhaven, or any other college or university, might be surprised to discover that blue jeans were not considered appropriate campus dress, even as late as 1957. Specific days were announced when students were permitted to wear blue jeans on campus. Pictured here, from left to right, are Wilamac Newton, Stella Rae Littleton, and Ellza Cottingham advertising "Blue Jean Day" for November 2, 1957.

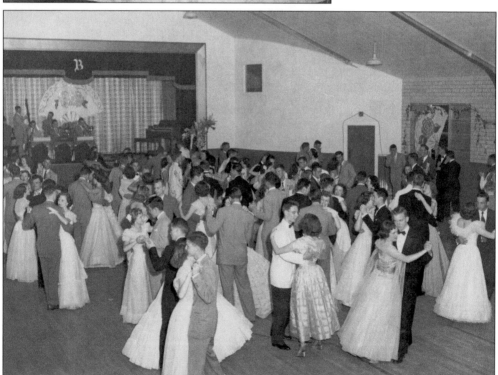

Today's Fine Arts Building was originally the recreation building, constructed in 1949, and today's Girault Auditorium was the gymnasium until Heidelberg Gymnasium was constructed in 1963. While still a gym, it also served as the site for such campus social events as dances. Students are shown here dancing to a live combo, probably in the late 1950s.

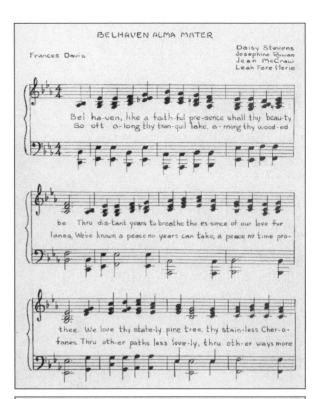

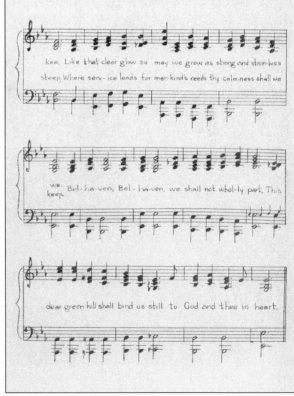

Belhaven's current Alma Mater, "Like a Faithful Presence," was introduced in 1940. The previous Alma Mater was "Here's to Belhaven" (see p. 97). The new Alma Mater arose out of an unofficial competition among members of Miss Dosha Dowdy's music composition class to write new music for a song to replace "Here's to Belhaven." The resulting music was composed by Daisy Stevens, Josephine Rowan, Jean McCraw, and Leah Fore. One afternoon in the spring of 1940, Susan Frances Davis was asked to write words for the new melody. After listening to the melody enough times to have it memorized, she wrote the words and turned them in to Miss Dowdy on the following Monday morning. The new Alma Mater was easier to sing than the original, and soon Belhaven College had a new school song.

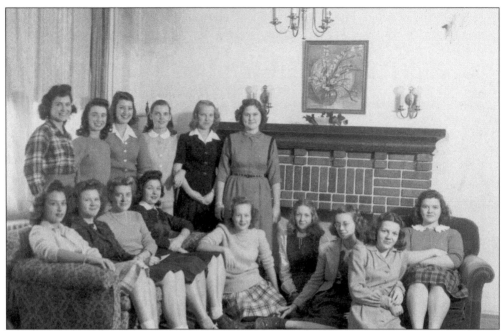

The Les Petites Soeurs was an organization of students who at the time had older sisters attending Belhaven College, or had sisters who attended Belhaven in previous years. It was sponsored by Miss Bess Caldwell. It sponsored weekend visits and parties for high school seniors and future "little sisters." The Les Petites Soeurs pictured here are those of 1946.

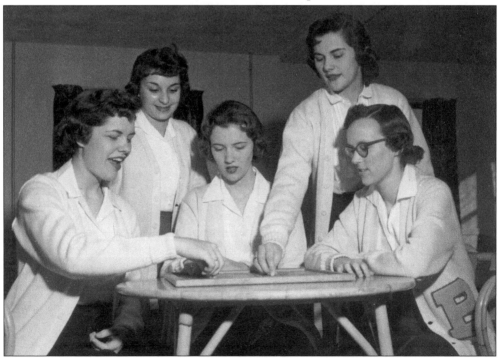

Members of the Tri-B Club of 1959 included, from left to right, Martha Jo Sumrall (secretary), Irene Vallas, Betty Bergland, Annette Fox, and Glenda Smith (president).

Seated beside the Lagoon are two "Campus Favorites" from 1953: Sue Carmichael (left), Miss Freshman Class, and Betty Lou Griffith (right), Miss Sophomore Class.

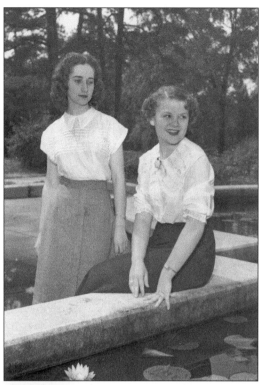

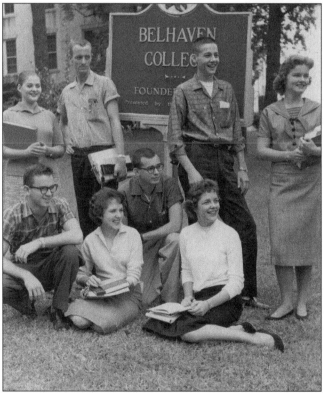

Eight students were chosen as "Campus Favorites" in 1959. Pictured from left to right on the front lawn, next to the Belhaven historical marker, are the following: (front row) Gaymor Phillips, Ann Mangum, Dwyn Mounger, and Martha Jo Sumrall; (back row) Jolene Cooksey, Joe Echols, Tommy Elkin, and Sandra Mathews.

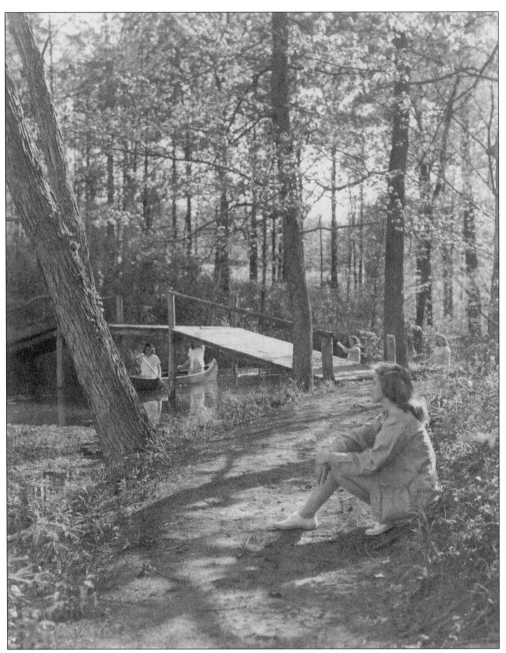

Until recent years, the campus of Belhaven College retained something of a wooded park atmosphere. The beautiful college lake, constructed in 1925, provided opportunities for boating and canoeing. Tree-lined paths along the lake provided ample opportunities for walks. The lake itself served as a backdrop for May Day festivals and other pageants. Virtually all of this rustic atmosphere has vanished, as Belhaven has taken on more of the look of an urban campus. The lake, much diminished in size since 1998, when part was filled in to provide a practice field for the new varsity football team, is now surrounded by the new Gillespie Residence Hall, tennis courts, homes, and the football field. Plans are underway in 2000 to place a fountain in the center of the lake, thus making it a sort of large lagoon.

120

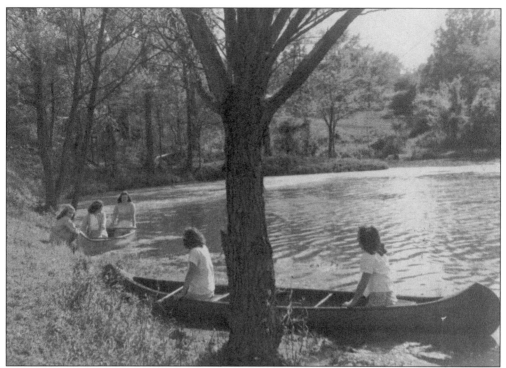

Students are seen here enjoying a canoe ride on the college lake, probably during the 1950s. Trees still stood next to the water. Much of the lake was still surrounded by a wooded park. The lake itself appears to be much cleaner than in recent years. Canoeing on the lake has long since ceased.

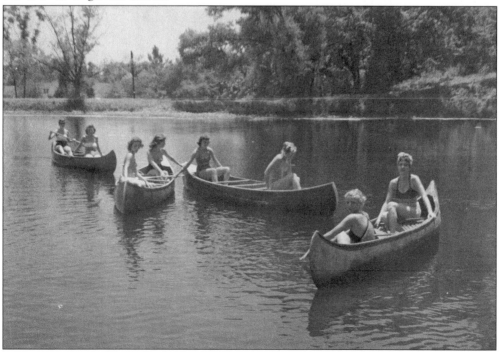

Canoeing was not limited to the college lake, as can be seen from this photograph of students in canoes in the Lagoon during the 1950s. No doubt this was a friendly prank. Peachtree Street is in the background.

It must have been a most unusually cold winter in Mississippi in 1962 when this picture was taken. It would be very unusual for it to get cold enough to freeze the water in the Lagoon, but to freeze it enough for Caroline Toler and a gentleman friend (identity not known) to skate on it, would be most unusual indeed.

When the Fine Arts Building was still the Recreation Building, a student snack bar was located on the lower level, where piano practice rooms are now located. The snack bar, known as "the Grill," was a spot where students could socialize, as is the case in this picture taken after a formal dance in 1956. Belhaven College becoming coeducational in 1954 resulted in a relaxation of regulations concerning student life. Still, by today's standards, student life in the mid-1950s was very constrained. Students were expected to attend church services on Sundays, and no athletic or other recreational activities were allowed on Sundays. Female students were allowed to attend dances at nearby Millsaps College and the University of Mississippi Medical Center, and off campus dating privileges were allowed only with written parental permission. It was in the 1960s, during the presidency of Howard J. Cleland, that the college ceased to assume the position of *in loco parentis*.

So long as members of the college's alumni continue to gather at homecomings to reminisce about their college days, Belhaven College will remain more than just an educational institution. Here two former students meet at Homecoming in 1999. They are Mary Katherine Knoblock (Layacono) (left), class of 1932, and Bettye Quinn (right), class of 1958. Mrs. Layacono is an artist, some of whose paintings are hanging on campus.

The Fifty Year Club (all alumni of fifty years or more) was started in 1982 by Mrs. Lynn Gillespie Beck, granddaughter of Dr. Guy T. Gillespie and a member of the class of 1974. Pictured here are the following, from left to right: (seated) Kathryn Busby Mangum, Erline Moss, Alice Wells Gillespie, and Hettie Lucy Bagby Vann; (standing) Lucille Rhymes Everitt, Edwina Cunningham Hubert, Emma McLain, Gladys Hughes Meisburg, Louise Fairman George, Annie Ingram Redd, and Lucille Griffith.

Five

A SECOND CENTURY

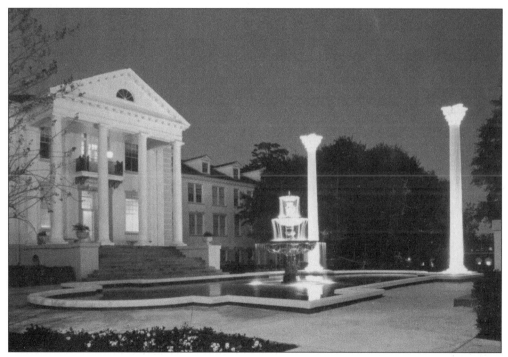

In 1999, the Lagoon, perhaps the most recognizable part of the campus, was completely renovated. A new fountain was installed, along with new Roman Corinthian columns like the original columns. In the summer of 2000, construction began on a new student center to be located between Bailey Student Center and Irby Hall, where Lancaster Hall once stood.

Dr. Roger Parrott became Belhaven's tenth president in 1996, and soon began an ambitious program of modernization and expansion to prepare the college to meet the needs of the rapidly changing world of higher education. Classroom space was added to Irby Hall, Gillespie Residence Hall was constructed, and an addition to Heidelberg Gymnasium was completed. The curriculum was expanded by addition of three master's programs: master of business administration, master of arts in teaching, and master of education in elementary education.

Satellite campuses were opened in Memphis, TN, in 1996, and Orlando, FL (pictured above) in 1999. Both offer programs leading to the bachelor of business administration and master of business administration degrees. Both programs began on the main campus in 1993, with the Adult Edge Excel program. Daniel C. Fredericks, provost (interim president in 1995), heads up both programs.

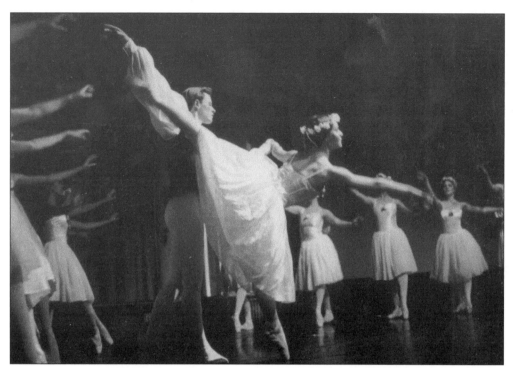

Every four years since 1990, Belhaven College hosts ballet dancers from all around the world, who come to Jackson, MS, to participate in the International Ballet Competition. Ballet Magnificat, a nationally known professional ballet company, began on the Belhaven campus in 1986. Today, Belhaven offers a bachelor of fine arts in ballet, under the direction of Mr. Marc M. Arentsen, that attracts students from across the nation.

As part of its efforts to meet the new challenges of higher education in the 21st century, Belhaven College became computerized during the late 1990s. By 2000, the college was beginning advance planning for a degree program that would be delivered over the internet. Campus offices were linked by computer in 1996, and the Hood Library catalog went on line in 1999.

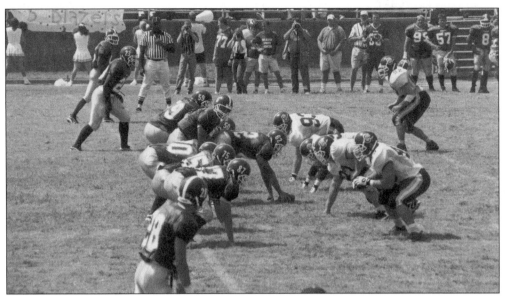

The new football program was announced in 1997. Under an able coaching staff headed by Coach Norman Joseph, the Belhaven Blazers football team was nationally ranked as high as 13th (NAIA Division I) in its second season of play (1999).

Commitment to its basic mission as a Christian college remains strong at the beginning of the 21st century. Student teams led by Dr. Joe Martin regularly go on short term mission trips. Members of the spring 1994 team to Mexico pictured here are as follows, from left to right: (first row) John Stone (RUF Chaplain), Joe Martin (faculty), Fred Quinn, and Peter Maynor; (second row) unknown, Becky Nordquist, Cathy Carman, Leslie Dickinson, Sean Palmer, Lydia Robinson , and Cynthia Loper; (third row) Keith Brown, Mathew Nasekos, and Michael Mounce; (standing at back) Wendi Shelton.